IN THE EYE OF THE SUN

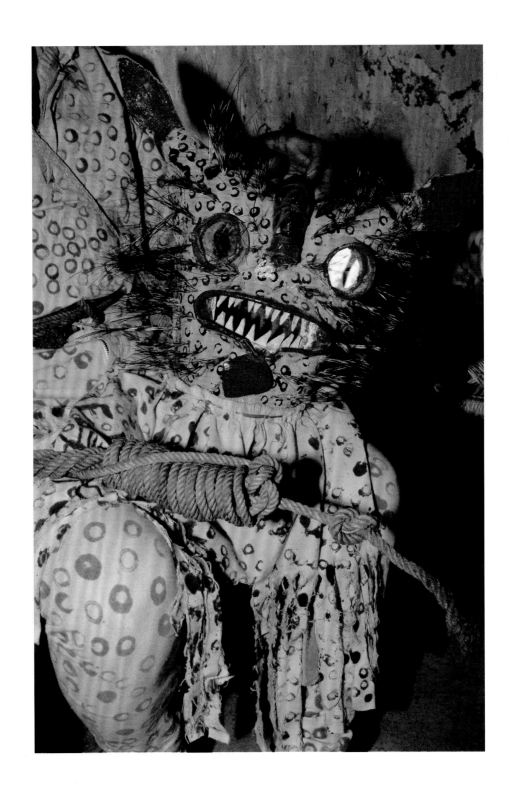

PHOTOGRAPHS BY GEOFF WINNINGHAM

INTRODUCTION BY RICHARD RODRIGUEZ

ESSAY BY J.M.G. LE CLEZIO

IN THE EYE OF THE SUN MEXICAN FIESTAS

A CONSTANCE SULLIVAN BOOK

W. W. NORTON & COMPANY, INC.

NEW YORK · LONDON

Library of Congress Cataloging-in-Publication Data:

Winningham, Geoff.
 In the eye of the sun : Mexican fiestas / photographs by Geoff Winningham ;
introduction by Richard Rodriguez ; essay by J.M.G. Le Clezio.
 p. cm.

 "A Constance Sullivan Book."
 1. Festivals–Mexico. 2. Festivals–Mexico–Pictorial works. 3. Mexico–Social life
and customs. 4. Mexico–Social life and customs–Pictorial works. I. Le Clezio,
J.-M.G. (Jean-Marie Gustave), 1940- II. Title.
GT4814.A2W56 1996
394.2'6972–dc20 96-32239

ISBN 0-393-04056-9
0-393-31584-3 (pbk.)

W.W. Norton & Company, Inc. 500 Fifth Avenue, New York N.Y. 10110
http://www.wwnorton.com

W.W. Norton & Company Ltd., 10 Coptic Street, London WC1A1PU
1 2 3 4 5 6 7 8 9 0

Frontispiece.
Dressed as a *tigre* (jaguar), a man awaits the dances and ceremonial fights in
which he will participate during the fiesta of The Holy Cross, Santa Cruz.
This spring festival has been celebrated by the Nahuatl people of central Mexico
since pre-Columbian times. (Zitlala, Guerrero).

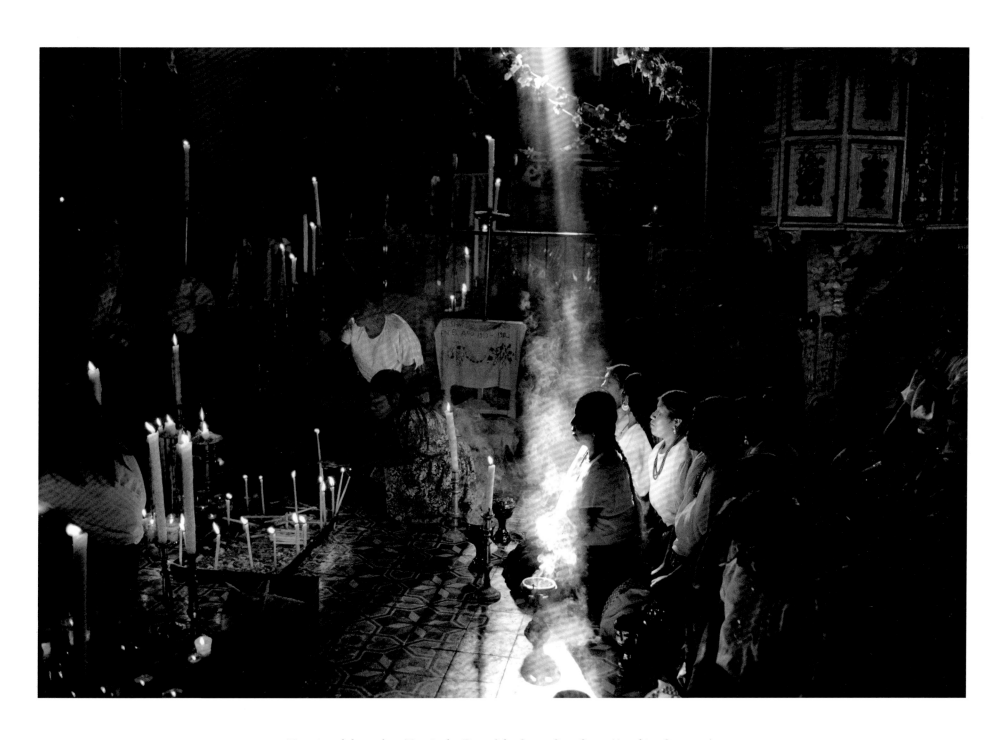

Mass is celebrated on May 3, the Day of the Santa Cruz fiesta (Acatlán, Guerrero).

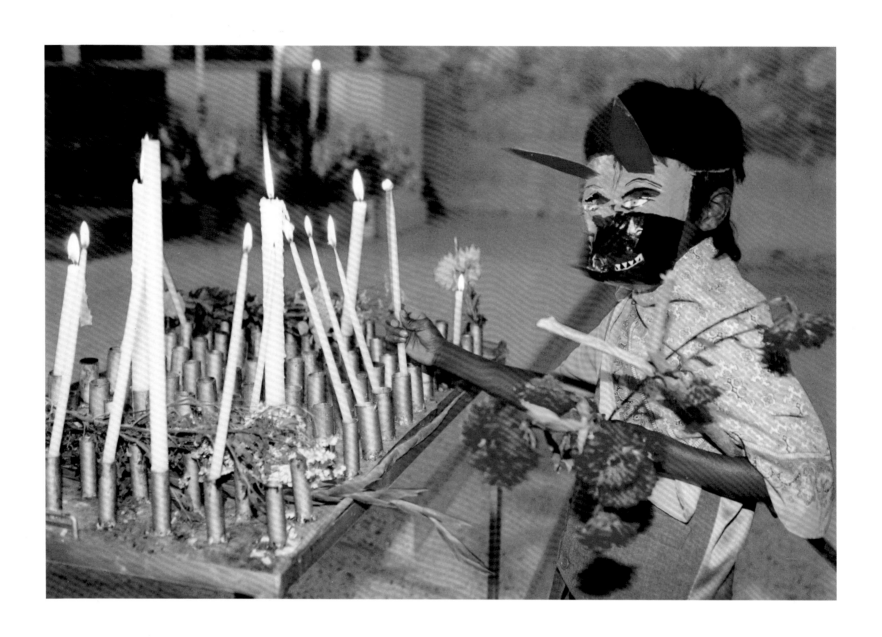

A young boy, masked as a perro (dog), lights candles in the church during the fiesta of Santa Cruz (Acatlán, Guerrero).

LA FIESTA RICHARD RODRIGUEZ

D ays, entire weeks, before a fiesta takes place, the preparations begin. There are costumes to sew. Masks must be painted with beatitude or pathos, the demonic snear, or the animal grimace. There are flowers to weave. Mole to boil to green. Wood must be fashioned into angelic wings. And the beast must be selected, cornered, its screeching neck slashed by thick unsentimental hands, its fear separated from its blood.

Spontaneity takes time in Mexico.

Spontaneity arrives on a specific date. For although the fiesta will violate the mundane, the fiesta is possible only because it exists on a particular day of the calendar year. Everyone knows exactly when. There are men of the village working in Los Angeles or Dallas who need to plan their return. Entire families who have moved to the city, they, too, need to know when.

You must believe in Zeus or God or the gods or the Sun to have a fiesta. You must believe that the heavens and the earth are in communication with each other. Pagan Indians believed; Christian Indians still do.

Secular Europeans and secular North Americans have lost faith in the divine, or perhaps in themselves as ceremonial creatures or perhaps in themselves as creatures at all. Our landscape is sterile, intellectual; we have bricked out heaven. We live without ceremony. We have our reasons, no doubt. But because God does not live culturally in the life of France or in Texas, entire planeloads of tourists cross the ocean or drive over deserts to watch the Indian fiesta with savage wonder.

Mystified.

In his essay on the Hopi snake dance, D. H. Lawrence mocks tourists who drive in their cars to watch a ritual from preindustrial civilization. "Three thousand people come to see the little snake dance this year, over miles of desert and bumps. Three thousand, of all sorts, cultured people from New York, Californians, onward-pressing tourists, cowboys, Navajo Indians, even Negroes. . . .What had they come for?"

A rhetorical question. Lawrence himself had traveled a lifetime from the industrial wastes of the England of his childhood, searching, searching for spiritual life. He too drove across the New Mexican desert in an automobile to watch thirty naked men dancing, dusty and sweaty, with snakes in their mouths.

Mad Lawrence, always scorning, always angry at an industrial world that had severed human connection to spirit. In another essay, he mocks his native England for refusing festivals, for not recognizing their loss. Instead of holy days, England has bureaucratically mandated "bank holidays." Commerce grinds down to silence on a bank holiday—that's what it means, all that it means. The family crowds into the tiny red Cortina, drives to the pale sea or to a dank stadium where two tribes of men kick a ball.

In California, where I live, organizers of San Francisco's "Carnival," in the Latino section of town, recently decided to move it—move the entire celebration— from one month to another.

Traditionally, in Catholic Latin America and southern Europe, Carnival is a week of excess and daring before the penitential shroud of Lent descends on the world. Remember that thou art dust, and unto dust thou shalt return. This being irrevocably the case, human flesh and human imagination riot—implying consent. That is Carnival. The root of the word is, after all, meat.

Oh, but in San Francisco the organizers of Carnival have determined that Lent comes at an inconvenient time of the year. They want a softer Sunday for their soulless Carnival. So they have cut it off from Lent altogether, plopped their Carnival down in late May.

Thus unanchored, Carnival has nothing whatever to do with any Christian

season (doubtless the intent of the secular organizers). San Francisco's Carnival merely becomes the occasion for several thousand Californians to strip down to gold bikinis and dance in the street. Amusing the spectacle may be, and entertaining, but it is not a fiesta anymore because it has nothing to do with God or even blasphemy.

With similar abandon, secular America moves our national holidays. The U.S. Congress has transferred various holidays to the nearest Monday in order to permit long weekends. Who, then, can blame tourists for traveling to Mexico to watch the fiesta? They come feigning curiosity, but with a certain desperation.

What the tourist does not see are the weeks of germination that prepare for the bloom of "spontaneity." Nor can the secular tourist always understand that the fiesta is much more than what is seen—sequins or green mole or masks. The fiesta is a celebration of objectified spirit. A fiesta revels in the marriage between the human world and the divine.

A headache.

In the noise and the bright sights of the day, the secular tourist feels a strain. The fiesta is like no secular holiday—nothing at all like Superbowl Sunday or Presidents' Day.

The water? the tourist wonders. The sun so uncomfortably close . . . perhaps what is needed is a chair in the shade of a tree.

It is neither the water nor the sun in the Plaza Mayor that unsteadies the secular visitor. It is the Indian's ability to live with a spirit world that we in Europe and in the United States of America thought had evaporated a long time ago.

Many fiestas begin just before dawn, with fireworks mocking the lazy sun. Man assumes the function of lighting the landscape; man creates the dawn; throws flares into the open windows of the court of heaven—the awakened saints peer down from their balconies with amusement. It is as though men have stolen fire from the gods—the most ancient of human dreams. Hormones light up the sky.

There is blasphemy playing in the air from the very beginning. Man impersonates God. In some villages, the strongest young men of the village strap themselves from a central pole and twirl down, in slow, even rotations, down, down to earth, all the while playing their enchanting Indian airs on violins. Men become angels.

Men! Men! Why not women?

I say, because the fiesta is foolishness and women have too much gravity. They are too much of earth, they bleed, they give birth, their bodies make milk, their hands create cakes and mercy. Weeks of preparation may take place in the kingdom of the woman—the house. But the impulse of the fiesta is outward, through the door, into the streets—the traditional province of the male.

Dong. Dong. Dong.

The priest in his black dress (dressed like a woman) rings the bell from the tower to summon the village to Mass.

In most Mexican villages, men tend to linger toward the back of the church during Mass. Women move more easily toward the front, kneel before their favorite saint, lighting candles, whispering prayers, asking God for this or for that. Women mediate between God and men every day of their lives. Praying (like weeping) comes easier to the woman in Mexico. It is harder for the male to kneel before the male God, to ask, to plead. Teenage boys, especially, keep their distance, barely enter the church. During Mass they tend to linger at the main doors and peer into the dark.

On the day of the fiesta, everything is different. The male has new confidence. And why shouldn't he?

On any other day of the year the will of God may be hard to decipher, harder to bear. Why has God allowed a drought to wither the fields? Why did God allow our mother to suffer with cancer for two years, before she died screaming, begging for death?

There are no answers.

The fiesta impersonates a divine motive. If not an answer, the fiesta supplies a droll rhyme—tears become sequins. The pleasure of the fiesta is that for one day the link between heaven and earth is certain. The air in early morning seems different, sweeter. The sky hangs at a slant unlike any other day of the year.

On most mornings, the priest assumes the power to change bread and wine into the body and blood of Christ. The Church has the power to declare certain days holy days. Once the day of the fiesta is established, however, the balance of power shifts. The predictability of the fiesta gives men a kind of control over the priest, over the Church, even over the heavens. They become priests for the day, sometimes priests of cruelty and derision; priests, nevertheless. Knowing the date of the fiesta even gives them a kind of power over God and his saints—the certainty of audition.

The men and women of the village start the fiesta by going to Mass. The men

put their cigarettes and their mescal on the steps of the church before they enter. But then something happens, toward the end of Mass. The patron saint of the village—the huge papier-mâché figure of Saint Michael or Saint Anybody—is hoisted onto male shoulders and is taken out of the church. The statue floats away from the building where it is usually surrounded by women and priests, floats down the steps of the church, into the male streets, into the real light of day, mingling with mescal and cigarette smoke.

Once such delightful blasphemy is achieved, anything is possible. Fiestas are famous for overturning custom, ravishing the everyday. There are Mexican villages where men dress up like women or cougars or tigers. Peasants impersonate kings. Indians become conquistadors. On such a day, wildness will run through the streets. Mescal will wash inhibition away.

Through the daylong masquerade, there is music. It is everywhere in the streets, often louder than voices. And there is dancing. Men don't walk if they can dance—ancient dancing, summoning the nonhuman alive. Whole groups of men will dance, their false women's breasts bouncing, their eyes flashing behind animal masks.

Christians become pagans again. Men become animals, fighting in a cornfield (as Indians did for centuries before Cortés and his flotilla arrived). Men dressed as animals lash one another with cords, as their ancestors did, hoping to cut their opponent's flesh, to appease the corn god with blood.

Meanwhile, planes may fly overhead—from Los Angeles to Mexico City. On earth, in the fiesta, man is no longer bound to calendar time. The fiesta frees man from the burden of time.

To have a good, a very good fiesta, it helps if the people of the village are very poor. Karl Marx would never understand. Capitalists would never understand.

I have heard American tourists predict the fiesta's demise, as though our own path toward secularism will be imitated by the rest of the world. I think rather that what might doom the fiesta in Mexico is Wal-Mart or Toys-R-Us.

To have a very good fiesta, you must use what is at hand—corn husks and turkey feathers, flour sacks and toilet paper rolls—to make Versailles. Mexican fiestas are handmade. They are sewn into being. Painted. Molded. Boiled. Cut. Every planet has to be sewn onto the sky.

The pleasure of the day, its mystery, is beauty. The everyday world is transformed. The village recreates itself in beauty with cheapness and brightness.

Everything is enchanting, nothing mundane. But the poignant enchantment comes from knowing that everything that is beautiful is also mundane. And will revert, when time reasserts itself.

Tomorrow the world will resume, assume its routine shapes and shades and boredom. But as long as the music plays, as long as the fiesta proceeds and the mescal flows, as long as Saint Michael dances, time is conquered.

On the Dia de los Muertos, a few years ago, I stood on the stage of the Annenberg Auditorium in the Palm Springs Museum. An elegant audience had come to learn about the Night of the Dead. But why? Everyone knows that Americans don't die—they pass away into euphemism. And Americans don't get old; they get plastic surgery.

Amidst the velvet and plush of the evening, my audience sat waiting. I didn't know how to tell my listeners that in Indian Mexico death takes place, certainly, but death is not final.

The Dia de los Muertos may not be a fiesta at all. For one thing, the day belongs more to the woman than the male. True, the entire family visits the ancestor's grave, eats and drinks among the gravestones. But it is toward the house (the woman's realm) that the spirits will travel, following the path of spilled marigold blossoms.

Inside the house, the women of the family have constructed an *ofrenda* with food and costumes and cigarettes and liquor for the dead to enjoy. The Dia de los Muertos reverses the play of mankind. At any other fiesta, humans pretend to be spirits, unbounded by time or circumstance. At any other fiesta, men can become gods, men can fly, can become animals or kings.

On the Dia de los Muertos, it is as though the dead have their own fiesta. The dead may show up at the door, disguised as a child or a stranger—best not to refuse hospitality to anyone who comes calling. The dead return to play at being human again, regard the treats their bodies once craved.

The dead come to eat and to drink and to smoke cigarettes among the living. In a way, their coming mocks our human fiestas. Mimics our celebrations of eternity. But in another way, the dead honor the custom of the fiesta. For by rejoining the human for one day in November, the dead remind us that the two worlds—heaven and earth—are inevitably joined.

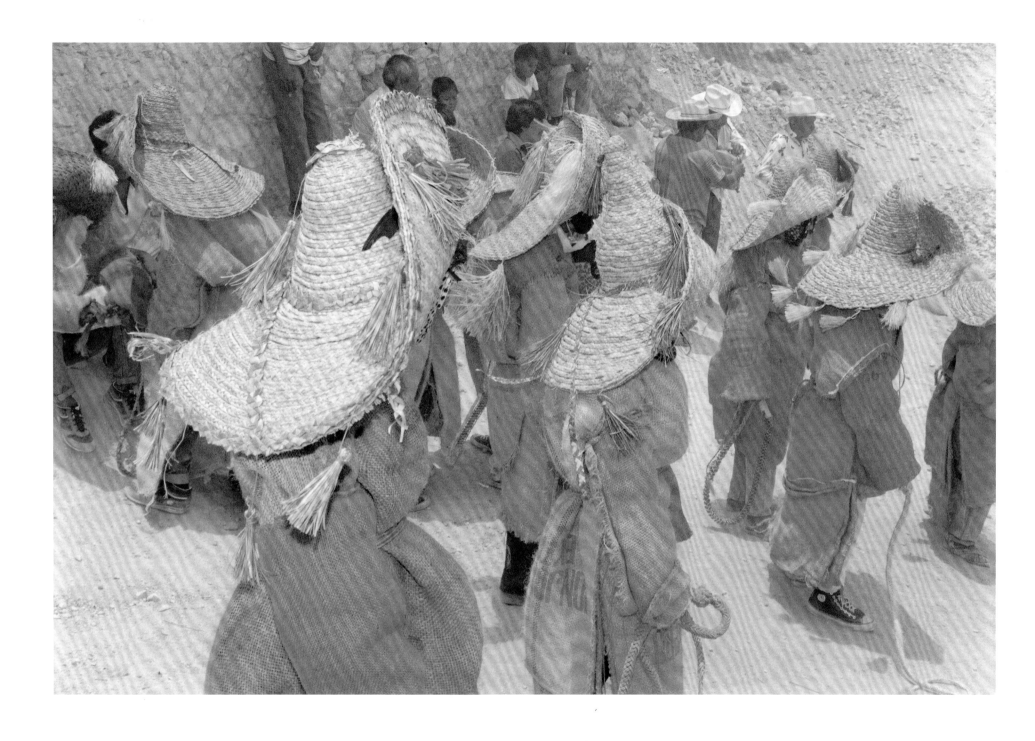

During the Santa Cruz fiesta, the dancing group *los tlacololeros* represents men burning brush and clearing the land for corn. During their dance to violin music, they mark the rhythm with whips to imitate a crackling fire. (Zitlala, Guerrero).

THREE INDIAN CELEBRATIONS J.M.G. LE CLEZIO

How can words describe Mexico and its festivals? Explanation and commentary seem superfluous next to the depth and truth of Indian celebrations, in which individuals lose their pride and don masks to become someone else. Geoff Winningham's photographs are not simply images. They invite us into the movements of the dance, urging us to put on our own masks, to lose ourselves in the violence and the truth of the ceremony. Rather than making specific comments about these photographs and about the feeling of urgency that they evoke, I was moved to speak of the Indian festivals that I have witnessed myself—and that have left me changed. The setting was the village of San Juan Parangaricutiro, in the shadow of the youngest volcano in the world (born when I was three years old); and again in Chun Pom, the village of the Cruzob Mayas, where one can still hear the echoes of the final shots of the Caste War. But I could not speak of Indian festivals without recalling some extraordinary shamanistic ceremonies of the Embera Indians of the Panamanian province of Darién. The Indian world knows no borders; it is magnificently, magically, of a piece. Its past is everywhere in evidence, from the frozen plains of the far north to the steppes of Tierra del Fuego, from the high Mexican plateau to deep in the jungle of Peten. Into this living past Geoff Winningham ushers us body and soul, as if into a dance.

It is said that the priest of San Juan received an order from the bishop: the scandal must be stopped. Those people, those Indians who came from the four corners of Michoacán, and even from neighboring states, to celebrate their pagan rite of dancing before the altar of Christ, had gone too far; it was unacceptable. The priest posted the injunction: henceforth, dancing would not be allowed in the church. Order appeared to be restored. However, one night, the priest was awakened by a noise, a familiar muffled sound coming from the church. Suddenly, he realized the Indians were violating the prohibition. They had managed to force open the church door, and they were dancing! Enraged, the priest rushed from the presbytery to the church. He tore open the door and lighted the lamps. But the church was silent and empty. Thinking he was imagining things, the priest went back to bed. No sooner had he done so than the noise began again, the rhythmic shuffling of bare Indian feet striking the floor. Ten times, twenty times, the same scenario was played out. Finally, at dawn, the priest understood: the Christ of San Juan Parangaricutiro, the omnipotent Christ who had stopped the tide of molten lava when the Parícutin volcano had erupted, did not like the priest's decision. Christ wished the dancing to continue in his church; this

was the form of prayer he favored. Thus the church opened its doors to the dancers once again, and from that day forward the practice has not ceased.

Christ loved this sound, which spoke to him, which was the sweetest music to his ears, which alone could soften his sufferings as the Crucified One: the sound of bare feet hopping in place in the center aisle, three steps forward and two steps back. No one speaks, there is no music, no praying, only the soft sound of all those feet striking the floor—men, women, and children, leaning slightly forward as if trying to read something, elbows held against their bodies, young and old, dancing right up to the altar, then skipping down the side aisles away from it.

Outside, the sun beats down on the canvas tents of the fair. In the winding alleyways, the faithful mix with tradesmen, idlers, and pickpockets, old market veterans and dumbfounded peasant women from Tanaquillo and Ahuiran. Buses deliver their cargoes of pilgrims. On the square, people come together from all over Mexico: Purepecha from La Meseta or from Lake Patzcuaro, Mazahuas, Nahuas, Otomis, Mexicans from Xochimilco. In the marketplace abutting on the church, everyone has something to sell or buy. Tarasco Indians from Tarecuato are squatting next to their buckets of chayotes, overripe pears, and small black avocados that look like olives. Mazahua women sit tirelessly before their stalls of embroidered fabric. The *jacaleros* came by bus from the far side of the sierra with their piles of earthenware jugs and pots that they are endlessly unwrapping and rewrapping. Children play with corn dolls and then fall asleep exhausted, in the shadow of plastic tarps. Tired pilgrims have set up precarious encampments against the outer wall of the church; they watch those arriving, those who will dance before the altar of Christ.

About four o'clock in the afternoon, the earth resounds with the muffled beating of the *teponaztle*, coming from the church choir. The sound is heard far away, all the way to the small square where the village band is playing polkas. The Indian drum sends out its imperious, violent call. Inside the church, the tightly packed crowd turns slowly around the *concheros*. The pilgims who were moving toward the altar have now turned toward the parvis, where the *concheros*, crowned with peacock feathers, dance to the rhythm of the drum. The beating of the *teponaztle* bursts forth beneath the vault, thumping like a giant heart that pulses through the very bodies of the faithful. Without even seeing the *concheros*, men, women, and children dance inside the church, close together, their faces impassive, while the rhythm of the drum accelerates. The drumbeat thunders louder and faster until it becomes a continuous rolling, like the rumbling of the earth when Parícutin was born fifty years ago. The feathers of the *concheros* tremble in the center of the church; even Christ is watching. Suddenly the noise ceases, and the silence that takes hold of the church is heavy like a stilled heart. Then the voices of the *concheros* echo in the nave, thin and high like the voices of little girls, mixed with the whining of the mandolins. It is a prayer, a song, the same sharp and unreal song that has been heard for millennia. The ankle bells of the dancers can be heard along with, once again, the soft shuffling of the Indians' bare feet. The smell of copal drifts up toward the center of the sky.

RITUAL SINGING ON THE TUQUESA RIVER, DARIÉN PROVINCE, PANAMA

In the province of Darién, among the Embera Indians, who are completely lacking in political organization or religious institutions, the ceremonial function is fulfilled by the *Beka*, a feast of song. This ritual is the most extraordinary moment in the peoples' lives, the moment that affords them the possibility of encountering the invisible forces that surround them and of treating the sick.

The singing festival calls for elaborate preparations. The Indians spend significant amounts of money and effort upon it, bringing together a

large number of people, both close and distant relatives. The *haibanas*, the shamans who treat the sick by means of incantations, are the only individuals of importance to the Embera. Respected and feared, the shamans—both men and women—actually wield such power in Embera society that the political power of the "free" caciques seems laughable in comparison. The *haibanas* hold sway over armies of spirits.

Several days before the singing ritual, the sick begin to arrive at the house of the *haibana*, accompanied by the members of their family who are to look after their needs. They are settled in a corner of the large house, not far from the entrance stairs. The ceremonial decoration of the house is left to the relatives of the sick, who create arches of woven palms, gather various scented plants, and supply balsa-wood statues that will be painted, following the *haibana*'s instructions, to represent the spirits, using the red of *lachiote (bixa oreliana)* and the blue-black of *kipara (genippa americana)*. Employing the same *kipara* sap, the sick and their attendants paint each other with an invisible ink that will be revealed over the next days as it oxidizes: long lines at the corners of the mouth, circles on the breasts and down the arms, jaguar spots and the interlocking triangles of the spearhead viper.

One or two days before the ceremony, the *Tahusa*, the ceremony of sight, begins. The sorcerer known as *Ihua Tobari* (the one who drinks the juice of the datura tree), having collected a fingernail's depth of the precious liquid in a coffee cup, drinks the juice and rubs himself with it, anointing his eyelids and the crooks of his elbows. During his trance, he sees the cause of the illness and recognizes the spirits that possess the body of the sick person, so that the shaman can prepare the treatment appropriate to each case.

That night, the *Beka,* or singing ritual, begins. At dusk is heard the sound of the shell trumpet, a conch brought back from the Pacific beaches; the *haibana* calls to the spirits through the forest. Soon, in the black night, seated on his little bench carved out of a single piece of wood, the shaman begins his chant. His piercing falsetto voice, almost superhuman, unfurls

like a slender thread that winds around the participants. In his left hand, the *haibana* holds his weapons, the magical staffs carved in fantastic shapes: two-headed men, monkey-headed men, hermaphrodites, women with oversized sex organs. In his right hand, he wields the broom of scented leaves, which he strikes on the floor rhythmically to call the spirits, to imitate their galloping through the branches of the forest and summon them to the offerings of bread, dried meat, and masticated *chicha*. The song becomes louder, unbelievably high and nasal as it imitates the spirits' voices, their snickering and gnashing noises; it hails from the other side of the world, from the spirit village on the far bank of the river. The spirits arrive on foot, running through the thickets or dancing across the water like flames.

The *haibana* is now standing near the kerosene lamp, dancing on the floor of the house, in front of the sick person's body. He dances in front of the altar laden with offerings, striking the floor with his staffs, his face twisting with grimaces. He trembles, threatens, by turns tender, mild, seductive, then violent, warlike, criminal. He creates theater in its purest, strongest sense. The attendants follow the rhythm of his song, swaying their bodies back and forth, chiming in themselves. Then suddenly the air is broken by the piercing cries of the *chiru*—the little single-noted flutes. Each flute sounding its one note, they converse in the night, exchanging questions and answers, like toads calling to each other.

The ritual singing lasts all night long. Sometimes it starts up again the following night, and again the night after that. Time no longer exists. The days pass rapidly, the nights burn without end. The *haibana* rests for an hour in the evening, while the attendants take care of the sick, bathing them, giving them food and drink, daubing them with *kipara* juice.

Then begins the ultimate ceremony, known as *kakwa hai*, the spirit body, during which the evil forces are drawn from the sick person, sucked and spit out, cast away. All night, the shaman and the attendants sing and dance, and when dawn appears, all the balsa statues painted as spirit effigies are thrown into the muddy waters of the Tuquesa, along with the

flowers, the bundles of branches, the perfumes. The *chicha* is passed around, and all wet their lips in the acidic potion, which is already bubbling with fermentation. Then the attendants immerse themelves in the cold water of the river for the first time. The young girls laugh and squeal, as young girls do everywhere when boys are watching them.

I wanted to describe the singing festival of the Embera Indians because participating in it radically changed my idea of art—the affirmation of another time and another reality that is art. Having once had this experience, I realized I could never again witness an art form more complete and more laden with meaning than this one, whose goal was not only to cure but also to restore lost equilibrium. In the *Beka*, I had found the most perfect form, the deepest expression that a human being can give to any quest. I do not know what has become of the Embera today, in a world in which war, terrorism, and drug trafficking have invaded the most isolated societies. I would like to believe that, in the night, here and there, the singing continues to burn regularly, drawing the evil spirits together in the clearings from all corners of the forest, to exorcise people's bodies and perpetuate their timeless dream of harmony.

THE CORN MASS IN CHUN POM, QUINTANA ROO, MEXICO

Seated beneath the great ceiba tree, the men look out at the half-circle of the village, at the corn fields, and, farther on, at the dark circle of the forest, where night is already falling. The village is like a mirage, with its walls of whitewashed mud and roofs of leaves. North of the square plaza is the guards' house and the temple of the cross. The women, gathered near the guards' house, are on their knees in the dust, grinding the corn in their mortars with the same regular, penetrating movements. On the other side of the plaza, the kitchens are ready, containing three large stones, embers glowing in the shadow. Already there is the smell of copal and of calabash-

seed soup. Naked children run in the last rays of the sun. The sound of hands shaping tortillas can be heard, a clapping sound that brings on hunger pangs.

For hours the men have been sitting in the shade drinking *balche* wine, cans of beer, *palomas*. Somewhere, under a roof of leaves, a radio croaks out a *cumbia*. A little to the side, in a shaded street, an old man dressed in white pajamas plays his Huastec violin—a shrill music that no one listens to. Sometimes the music drifts away, the violin falls silent, the women stop working, and a strange crackling noise is heard, perhaps the sound of the light. The sun inches slowly toward the red mist emanating from the copal forest.

At nightfall, the men walk to the house of Segundino Coh, carrying bowls. They form an unruly procession, somewhat drunken, preceded by half-starved dogs. The men head toward the church. With them is an orchestra: a violin, guitar, and a large drum. Leading the way are the elders, dressed in white and shod in sisal sandals.

Barefoot, the young men have entered the temple of the cross. They have placed their bowls of meat, calabash-seed soup, and tortillas in front of the large cross dressed in an embroidered robe. To the left of the cross stands an empty chair decorated with hibiscus flowers. Inside the church, the shadow is thick, perfumed with copal. The dim flames of the tapers glow in the darkness like red stars, recalling dogs' eyes. Kneeling on the floor, men and women murmur prayers, their arms in the form of the cross. The murmur intensifies, swells, gains force like a gust of wind, like heavy thunder. The priest stands before the cross. He too is clothed in a woman's dress, like the robe draping the cross. He speaks to the cross, which towers over him like a giant; he speaks to the statues clothed in blue and crimson. Then he kneels before the empty throne. One by one, those who brought the bowls lean over the kneeling elders and murmur in their ears some secret message. Perhaps it will be tonight: perhaps the king will return, swaddled in woven straw, to the central square of the village. Then the guards will take

up their arms again—the old rifles sold them by the English from Belize—and they will deliver the Cruzob Mayas from the yoke of the Mexicans.

The men have gone out onto the square. The villagers, the people from Quintana Roo, those from Tulum, from Chancah, from Tixcacal, from Xjaxil, from Tihosuco—all of them are there, before the temple of the cross; seated in the shadows, they wait. Some of them continue to drink their beer and their *palomas*. Children can be heard laughing. Somewhere, an edgy rooster raises its crowlike voice.

The sky is black, gleaming, icy. In the fireglow, the young men of the guard march across the square, carrying the sacred species for the great Communion—the softest of tortillas—and the bowls of calabash-seed soup that burn like the jaguar's tongue. There is music, and the bursting of fire-crackers—perhaps they make the heart of old Segundino quake. Perhaps he thinks at this moment of the Separated Mayas, the ones that General Bravo's troops could never rejoin in the shadowy forest. Perhaps he hears the last words that Juan de la Cruz Ceh dictated to his secretary Yum Pol Itza, the night before the city of Chan Santa Cruz (now Felipe Carrillo Puerto) fell:

> There is one more thing I must say to you, my dear Christians, sons of the villages. You can see me as I am; I am but the shadow of a tree, but all of you, great or small, can see me, and also those who think themselves above others, for my Lord did not put me on the side of the rich, he did not put me on the side of the generals or commanders; my Lord did not put me with those who claim to have a lot of money, nor with those who say and believe that they are worthy and powerful; my Lord put me on the side of the poor, the wretched, for I am poor, I am the one my Master pities, and he loves me, for the will of God is that whoever gives to me will see his goods multiply. Is there another God?—tell me, for I am the master of heaven and earth, and all the people of the villages are my children.

The moon rises in the black sky and casts its glow on the white dust of the square and the streets. The soft bread fills the people's bodies, and the calabash-seed soup flows in their blood. Slowly, one by one, the fires go out. Little children sleep nestled against their mothers, close to the hot ashes. The night cold makes the stones crack and the trees contract. The old radio is still croaking its *cumbia*, far away, as if from the other side of a dream.

J.M.G. Le Clezio
Translated from the French by Jennifer Curtiss Gage

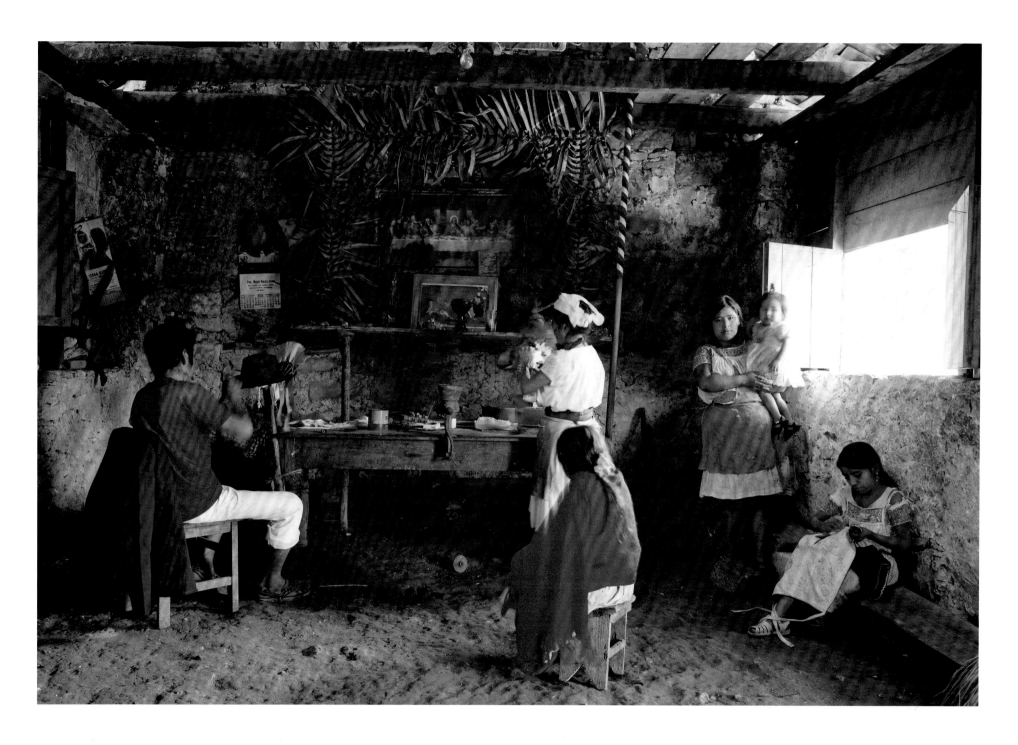

A village family prepares for the upcoming fiesta of their patron saint, San Miguel, by making the costumes they will wear for the three-day-long festival (Zinacapan, Puebla).

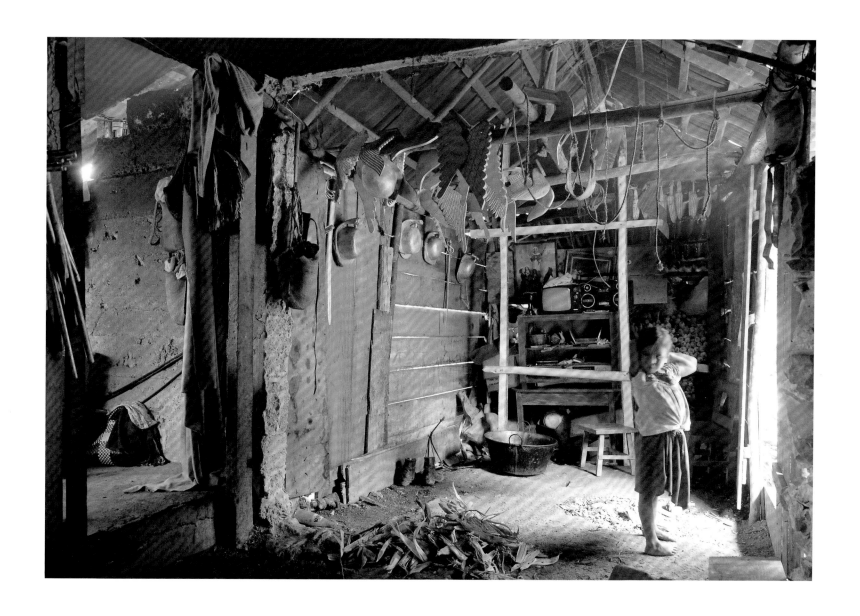

The walls and ceiling of a home are covered by recently carved and painted helmets, swords, and shields for the *miguelitos*, one of the dancing groups that will participate in the local fiesta on the day of San Miguel (Zinacapan, Puebla).

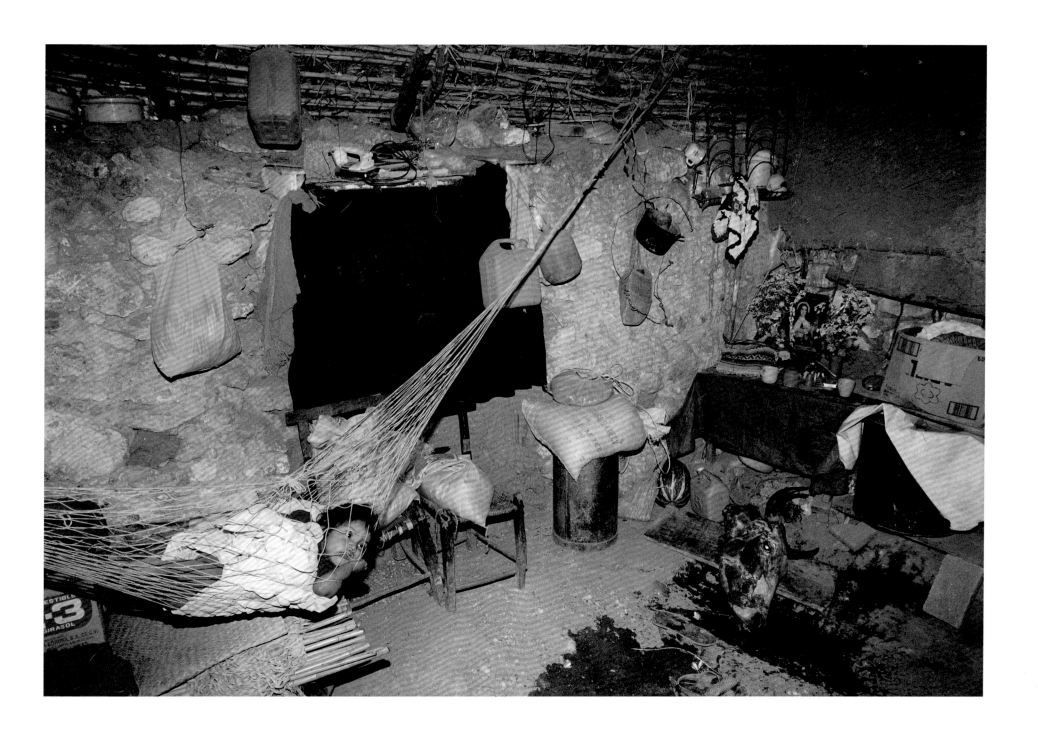

On the floor beside a child resting in a hammock is the recently skinned head of a bull, which will be cooked for the fiesta of Santa Cruz the next day (Zitlala, Guerrero).

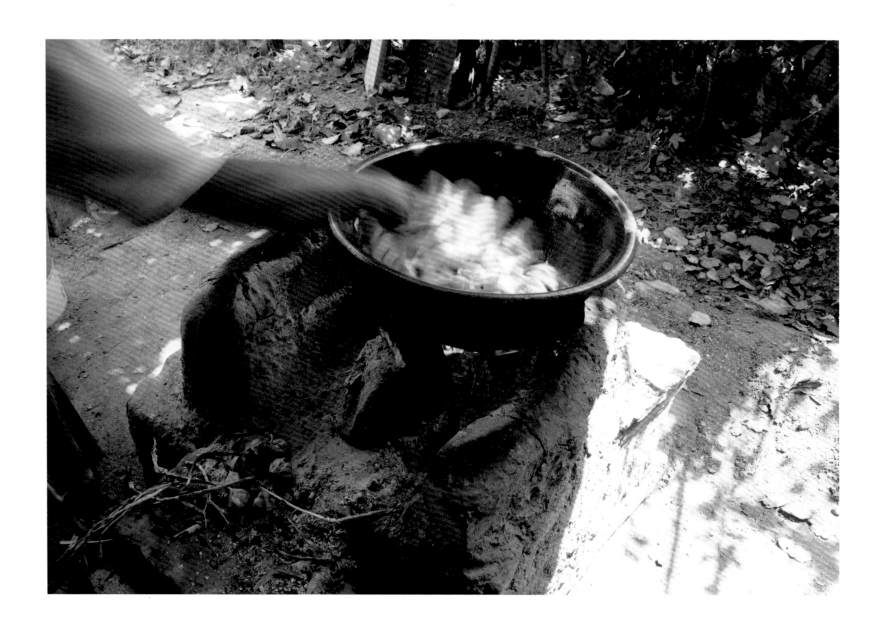

The making of mole, a complex sauce of many ingredients and spices, begins with the cooking of sliced apples.

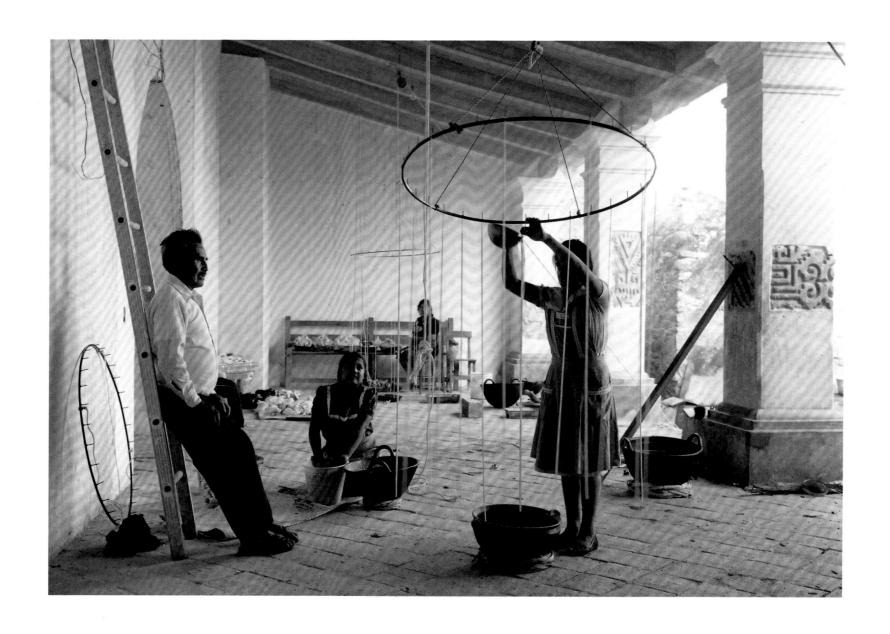

Women in a Zapotec village make long candles for their fiestas by repeatedly
pouring molten tallow down strings hanging from circular frames (Teotitlán del Valle, Oaxaca).

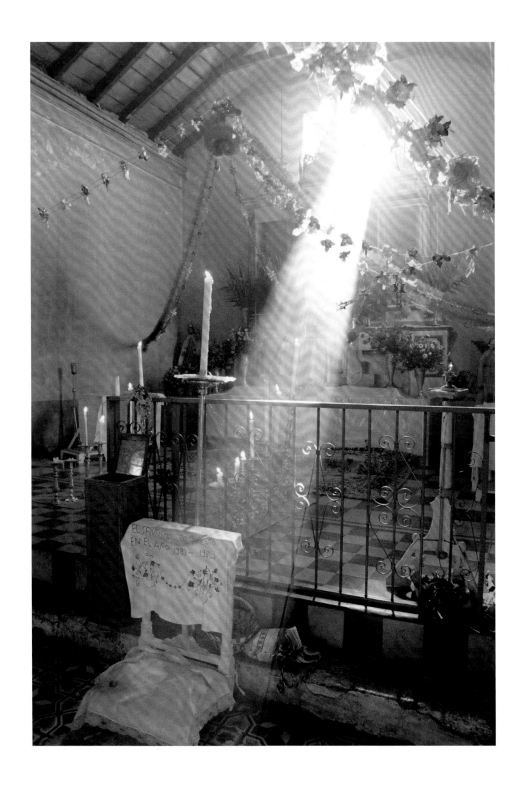

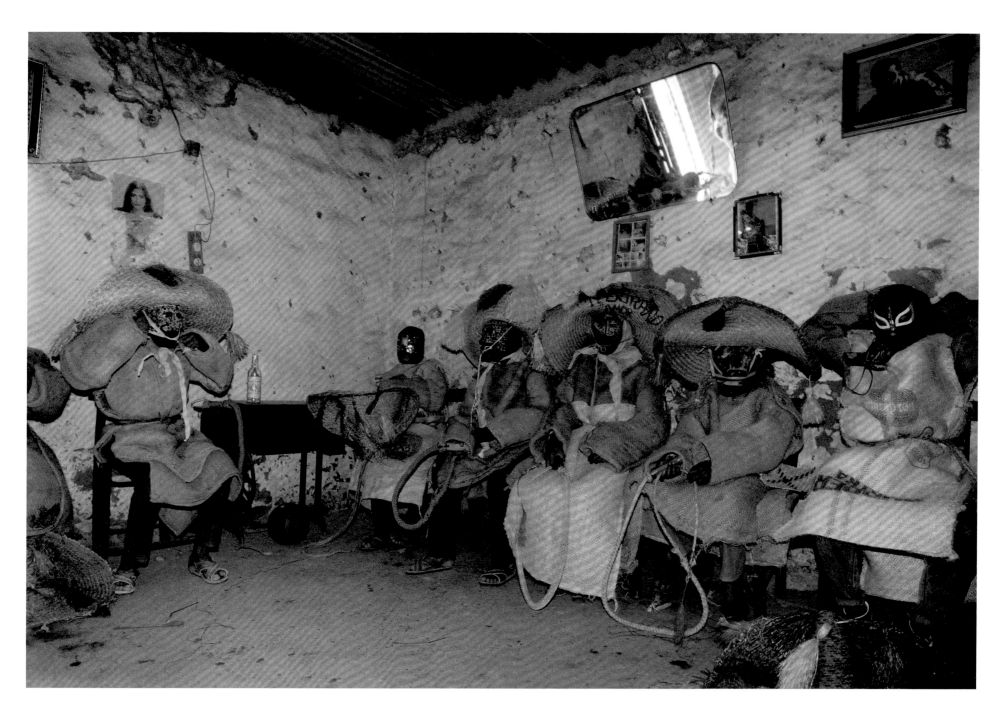

The dancing group *los tlacololeros* awaits the beginning of the Santa Cruz fiesta. (Zitlala, Guerrero).
Opposite. The main altar of the church is decorated for the mass during the fiesta of Santa Cruz (Acatlán, Guerrero).

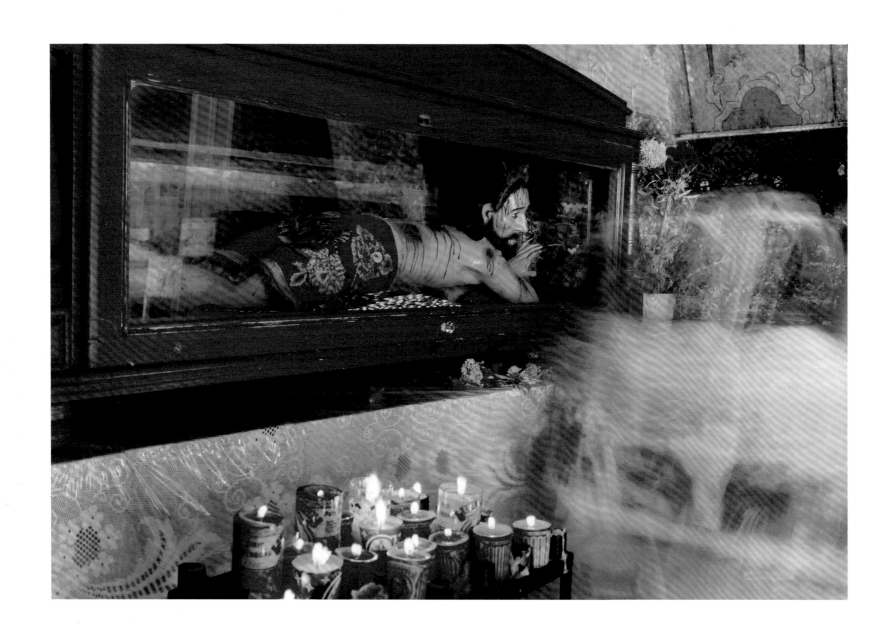

Candles are lit and donations placed in the church on fiesta day (Santa Anna del Valle, Oaxaca).

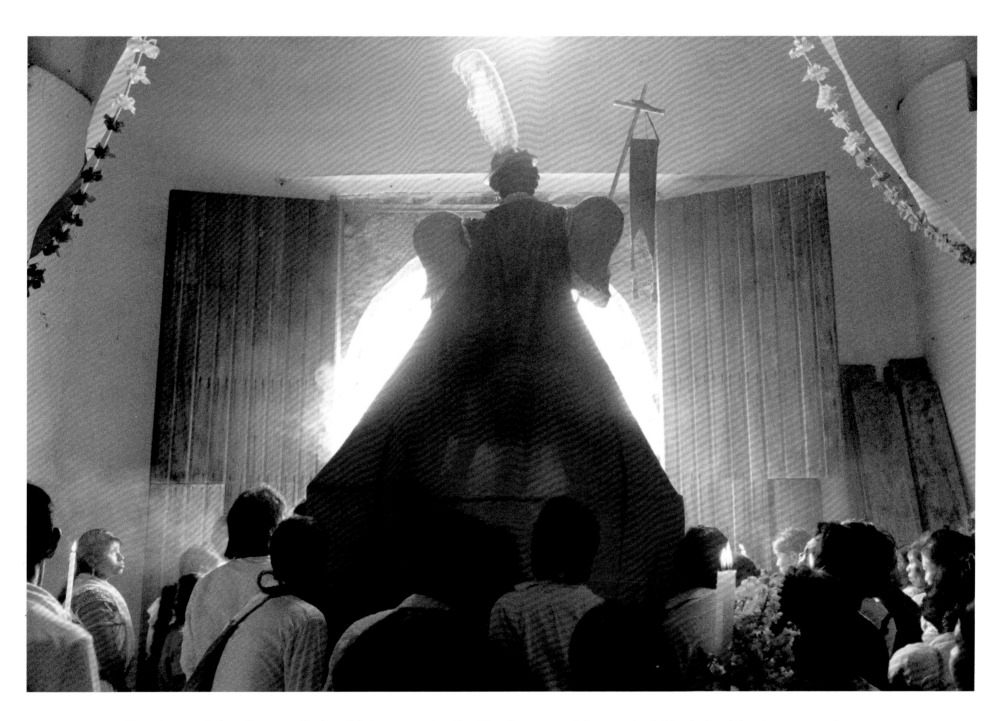

Upon the completion of mass on the day of their patron saint, San Miguel, a ceremonial procession led by the local dancing groups and women bearing candles and flowers carries the carved figure of the saint from the church into the village streets.

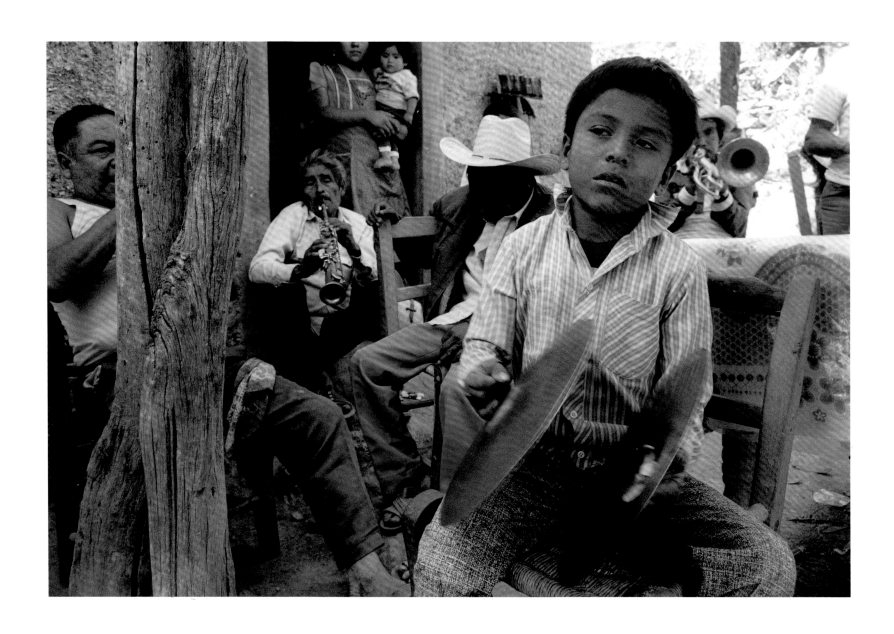

Early on the first morning of the fiesta, a band plays in the home of the *mayordomo*
(the keeper of the saints' images and chief of the local fiesta). (Temalacacingo, Guerrero).

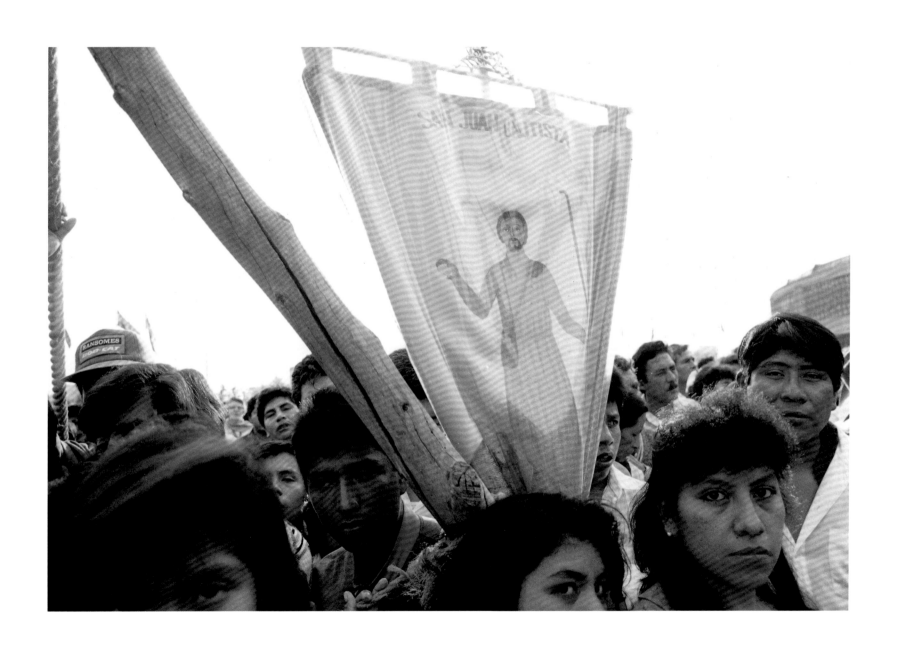

A banner with the image of their patron saint, San Juan Bautista, rises from amidst the crowd at the fiesta of the Virgin of Guadalupe (Mexico City).

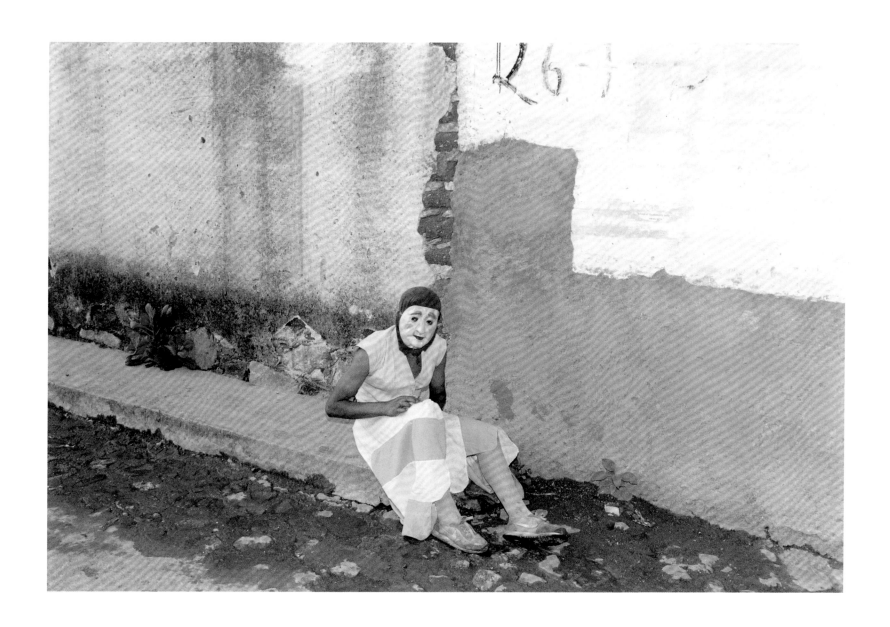

On the day of this village's patron saint, San Francisco, most men–including prominent
citizens–dress and mask themselves as *tecuanes*,which here means dressing as women (Olinalá, Guerrero).

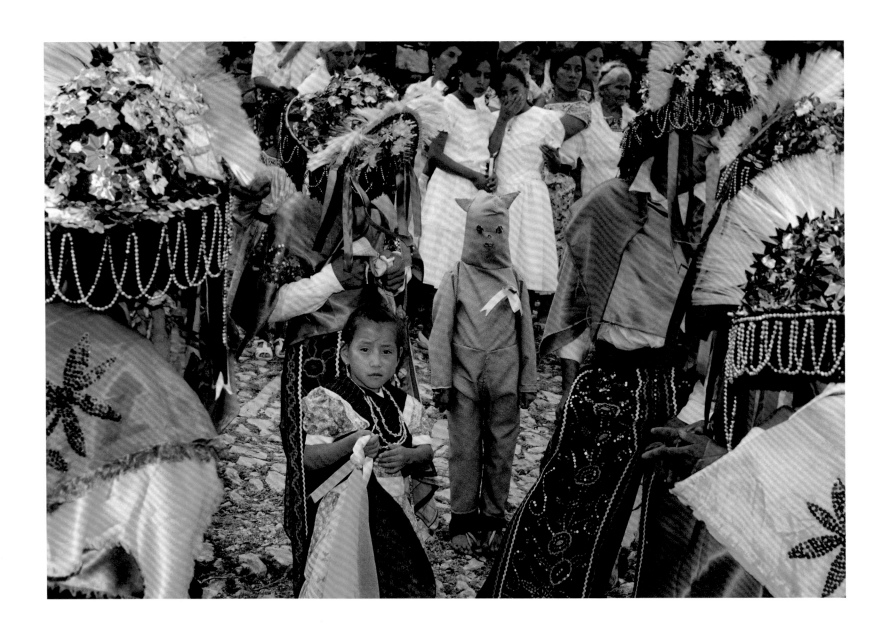

As part of a fiesta procession, a young boy dresses as a devil, in a homemade costume (Zinacapan, Puebla).

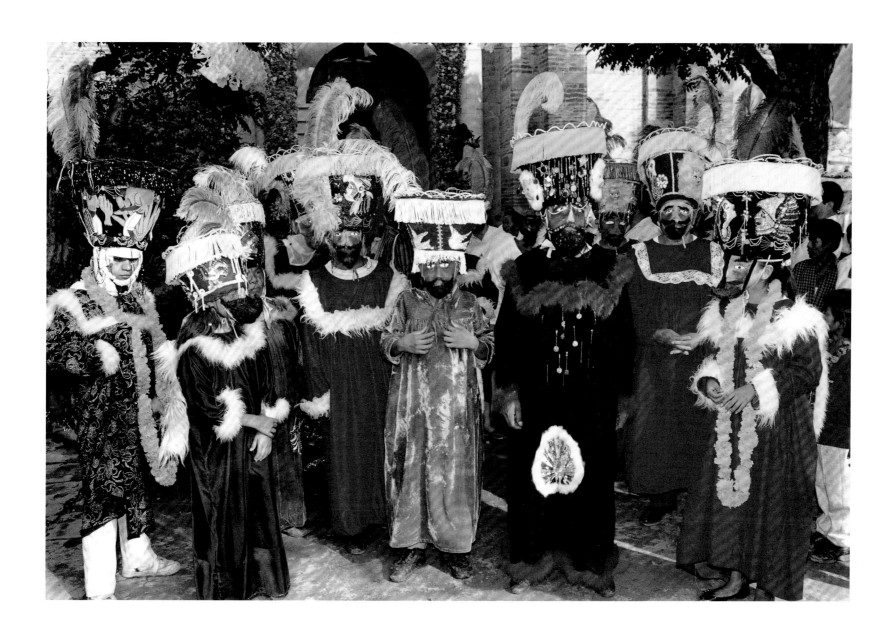

A dancing group from the state of Morelos, *los reyes* (the kings), pauses during the main procession during the fiesta of San Francisco (Olinalá, Guerrero).

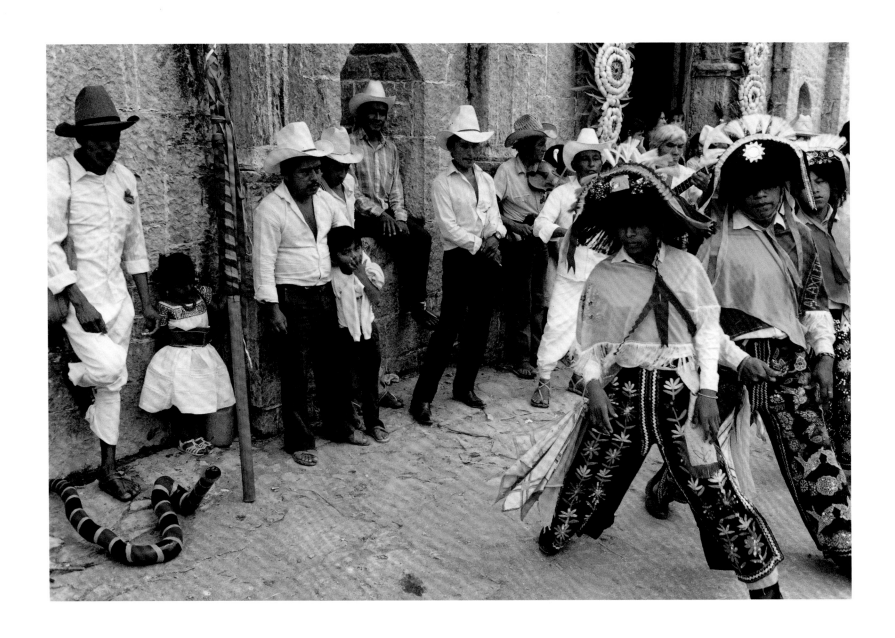

The traditional dance of *los negritos* is performed in front of the church during the fiesta of San Miguel (Zinacapan, Puebla).

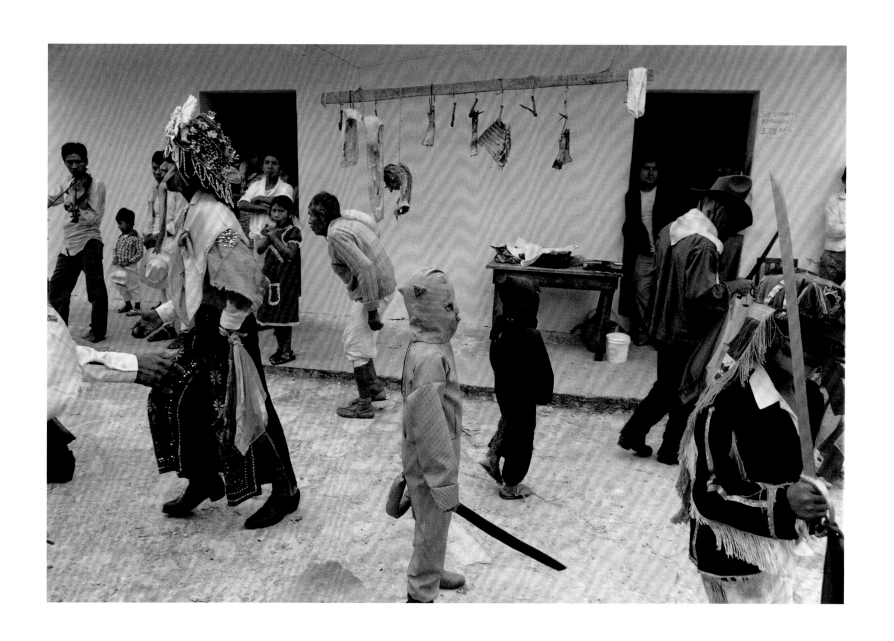

Dancers in a fiesta procession pass a meat market (Zinacapan, Puebla).

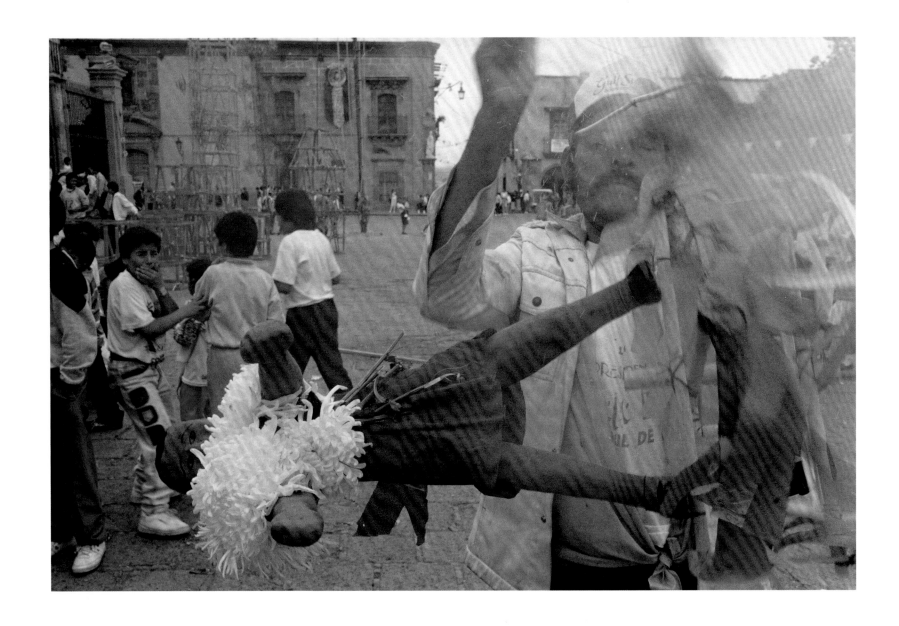

On Easter Sunday, paper-mâché figures of the traitor Judas, filled with firecrackers, are ceremoniously exploded on the *zocalo*, or central plaza (San Miguel de Allende, Guanajuato).

Opposite. One of the most elaborate of the Mexican celebrations of Carnaval, the Huejotzingo fiesta is celebrated for three days preceding Lent. This man is dressed in the costume of a *serrano*, one of the poor mountain people who joined the Mexican troops to defeat the French army in the battle of Cinco de Mayo (Huejotzingo, Puebla).

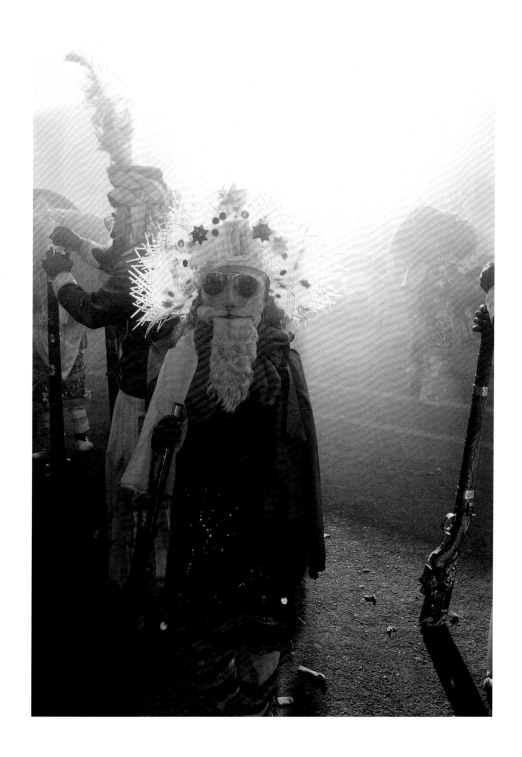

Opposite. (left) A dancer performs in traditional costume (Santiago, Guerrero).
(right) A man with an improvised costume, including the head of a bull, parades at the fiesta of *los locos*
on the Day of San Antonio (San Miguel de Allende, Guanajuato).

Page 40. Horses and riders are both elaborately costumed for the fiesta of Santiago (Timgambato, Míchoacán).

Page 41. A woman in the traditional dress of a Mixtec shops for fiesta goods in the main market (Oaxaca).

Pages 42–43. Four fiesta masks a *rey* (Morelos); an *hombre* (Puebla); another *rey* (Morelos); a *diablo* (Suchiquiltonga, Oaxaca).

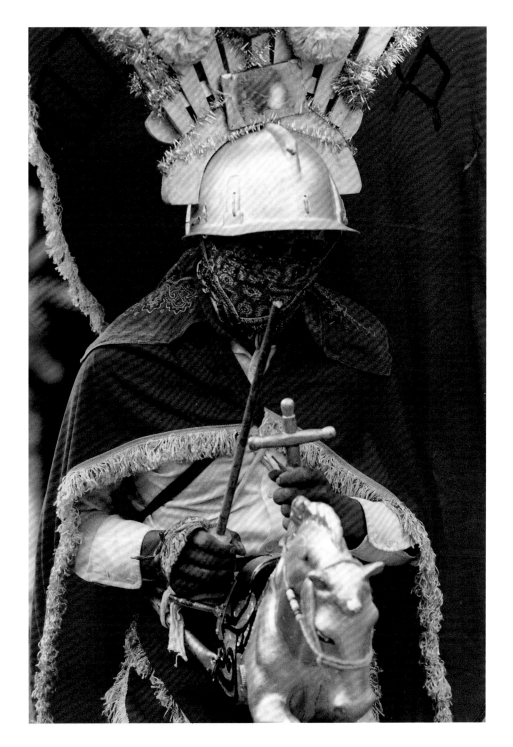

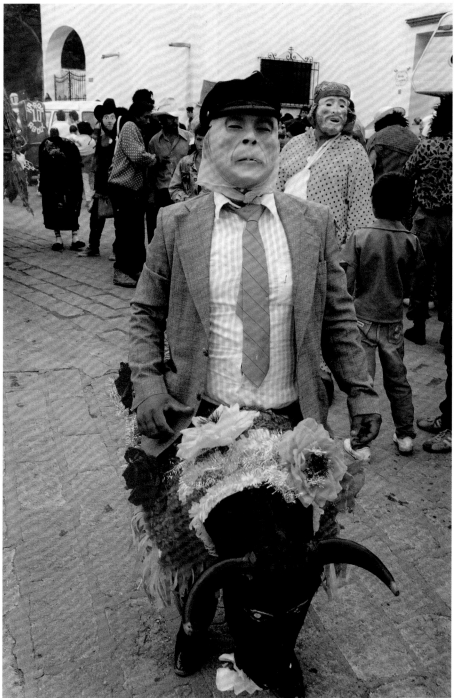

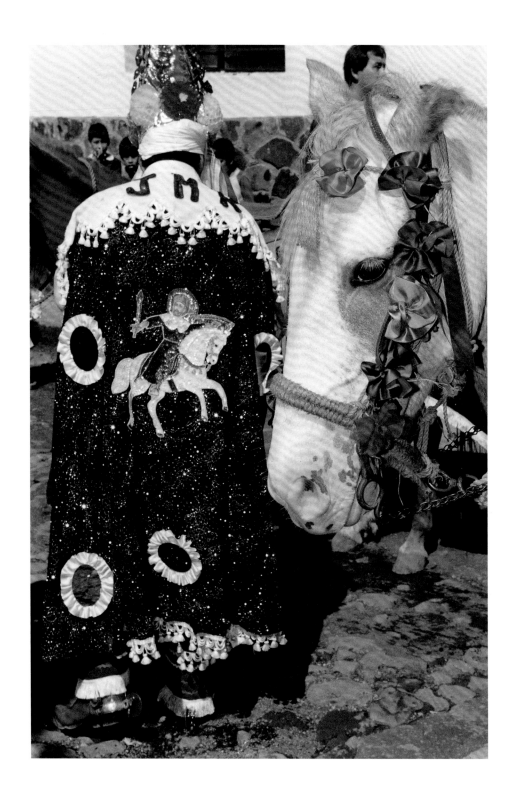

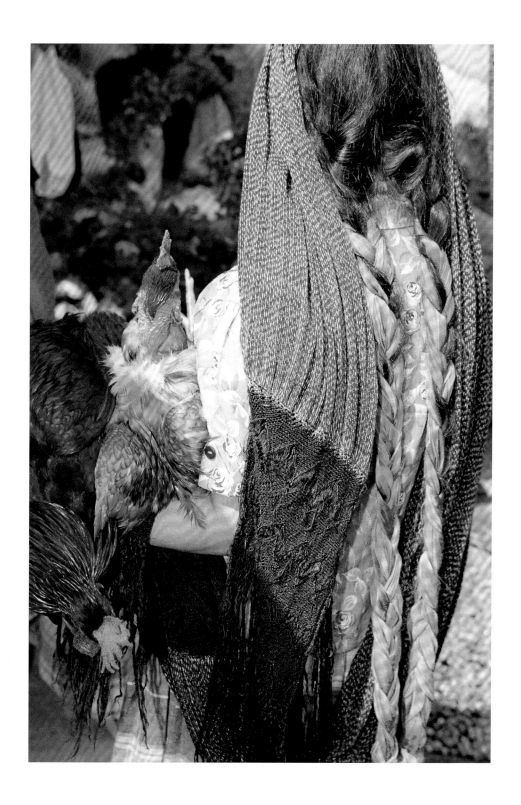

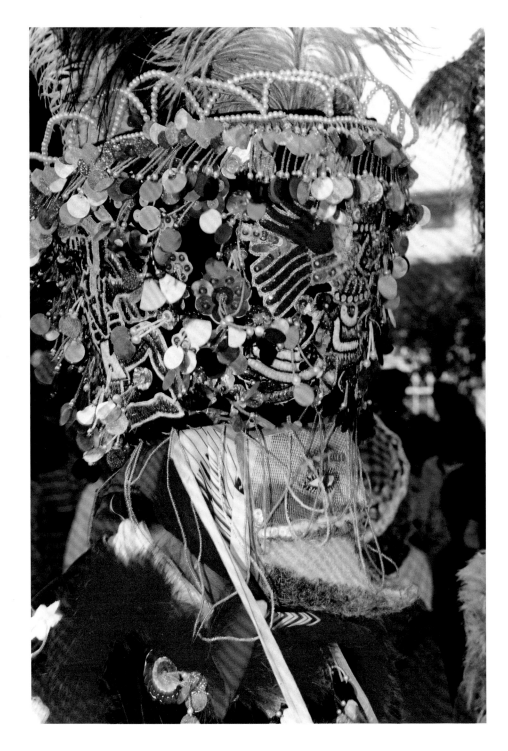
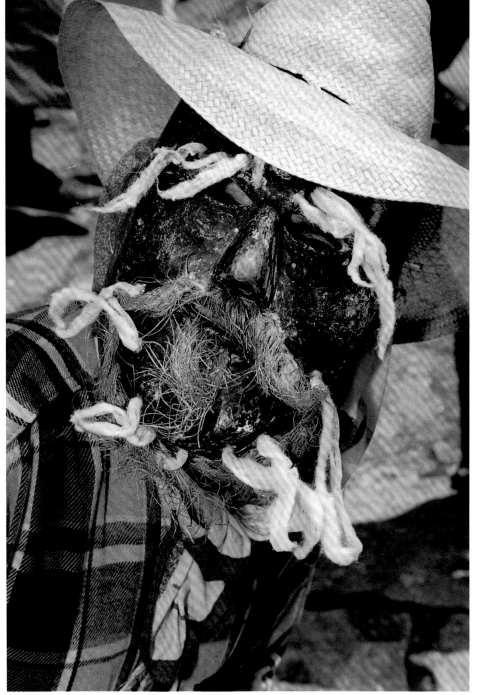

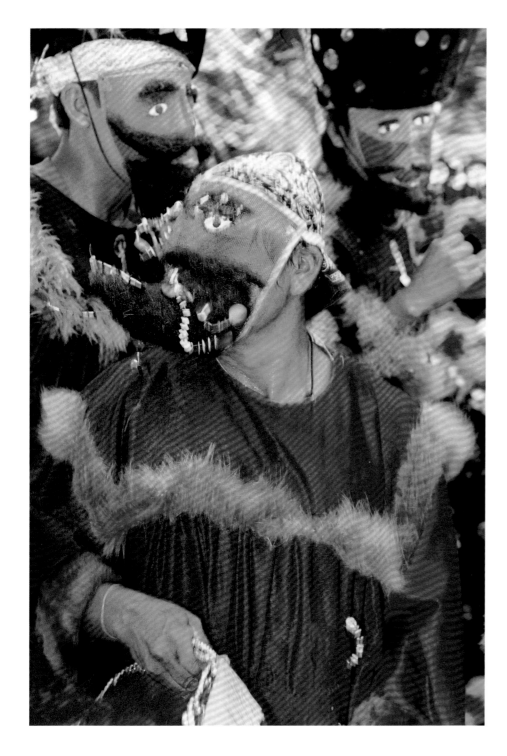

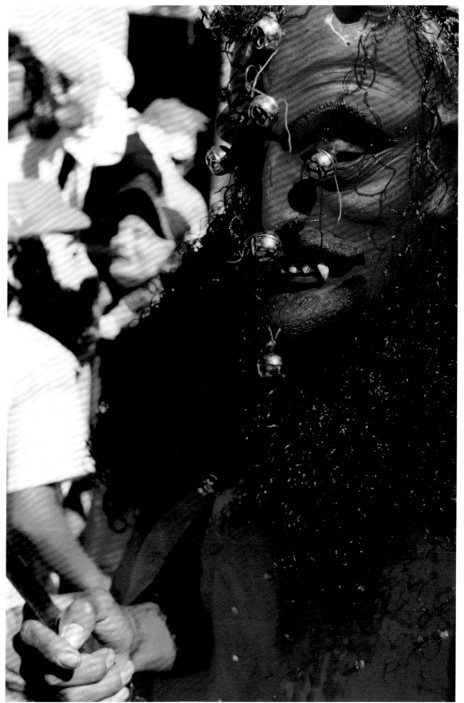

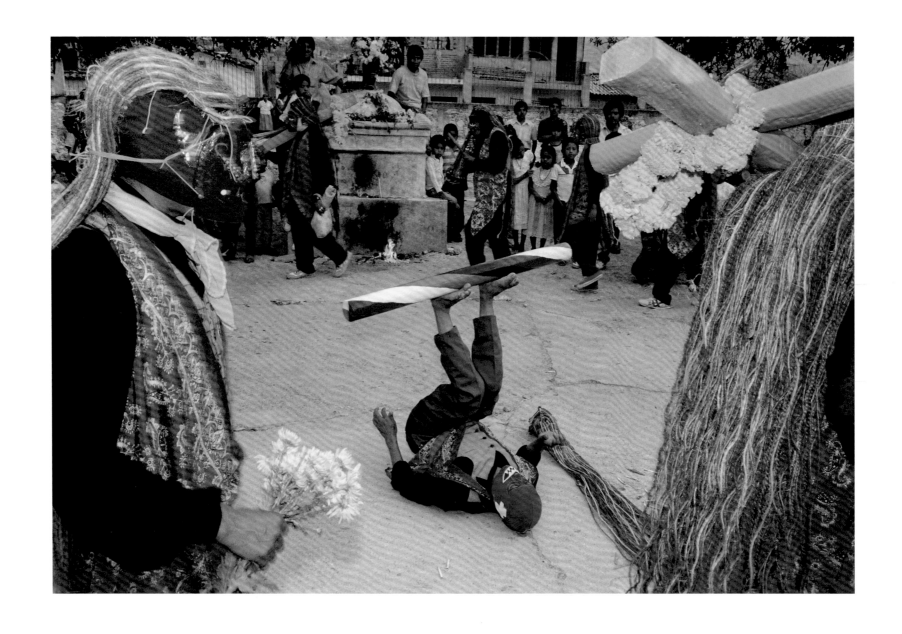

Huiquixtlis, wearing their distinctive costumes of long, multicolored hair and carved wooden masks,
perform at the fiesta of Santa Cruz. Performed since pre-Hispanic times, their dance is a rain-bringing ceremony, an integral part
of the fiesta, which occurs at the time of the corn planting (Acatlán, Guerrero).

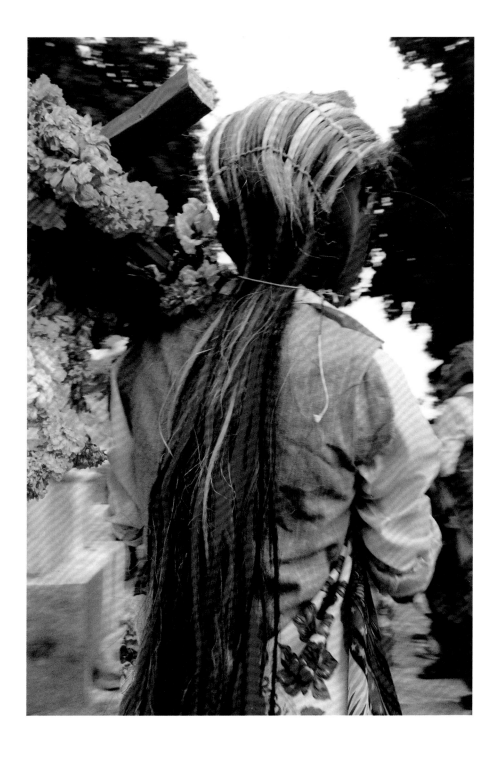

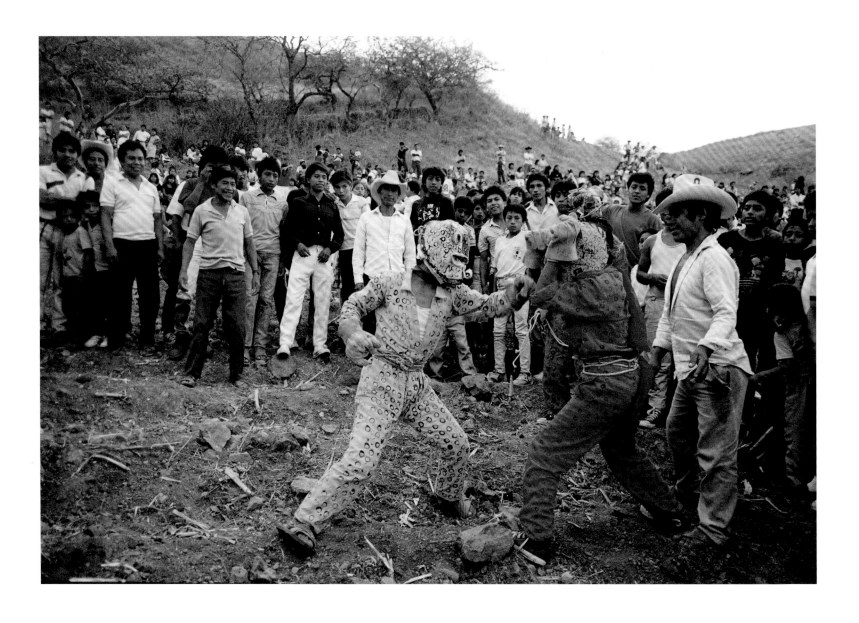

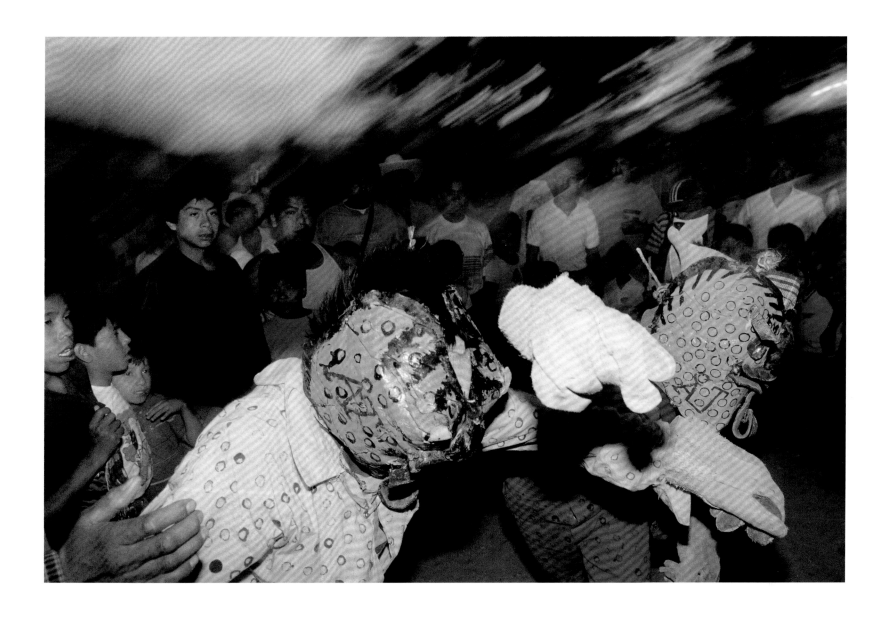

In a cornfield on the edge of the village of Acatlán, men dressed as *tigres* (jaguars) fight furiously in front of a crowd of local people. Such fights can be traced to the days before the Spanish conquest, when the combatants fought to the death, believing that their blood pleased the god of the sun, fertilized the soil, and insured a good crop of corn.

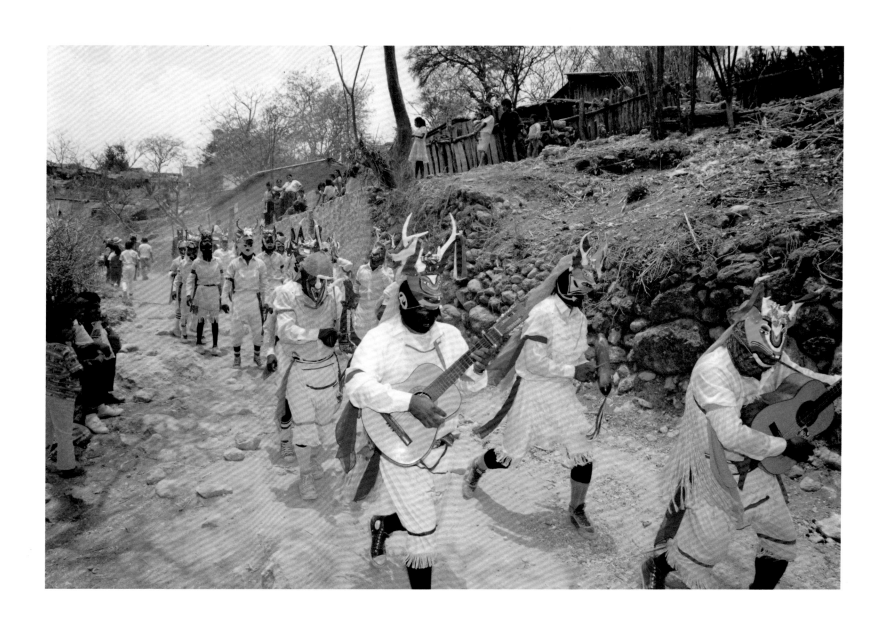

Los chivos (goats), another local dancing group, arrives at the fiesta of Santa Cruz (Zitlala, Guerrero).

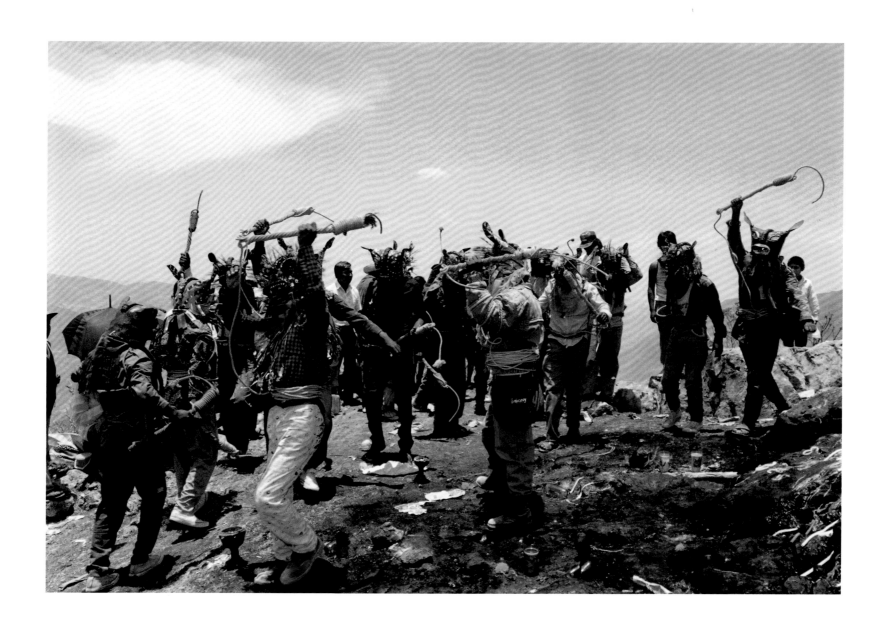

On the day before the fiesta of Santa Cruz, most of the people of Zitlala climb to the top of a nearby mountain, where all the local dancers will perform. The *tigres*, who will fight with ropes knotted into whips, let off steam until the fights can begin (Zitlala, Guerrero).

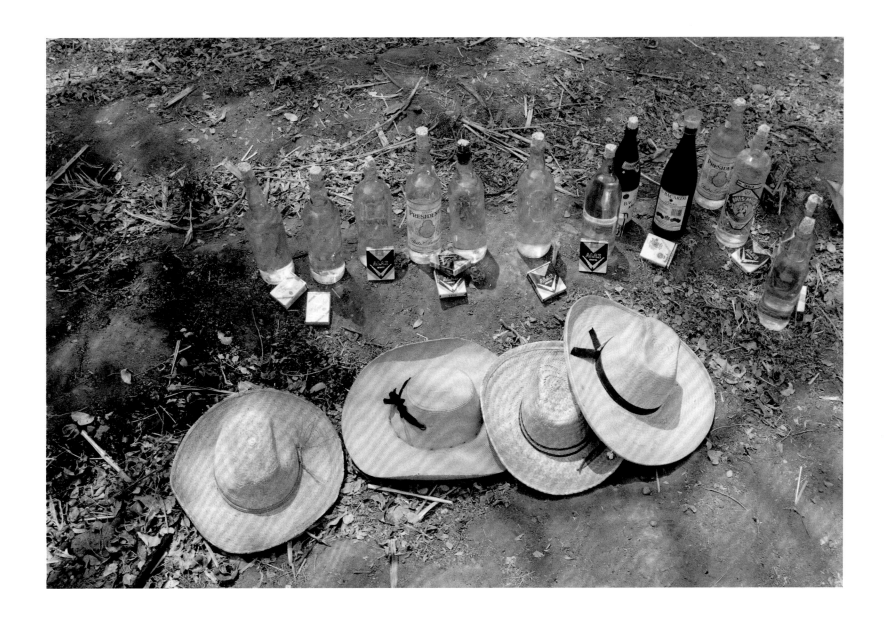

Sombreros, home-brewed mescal, and cigarettes are laid out while the men attend mass. Afterward, as dances and other festive fiesta celebrations begin, the men will drink and smoke (Zitlala, Guerrero).

A penitente (penitent), wearing a crown of thorns and a crucifix, has arrived
on his pilgrimage to the church for "spiritual exercises" of repentence (Atotonilco, Guanajuato).

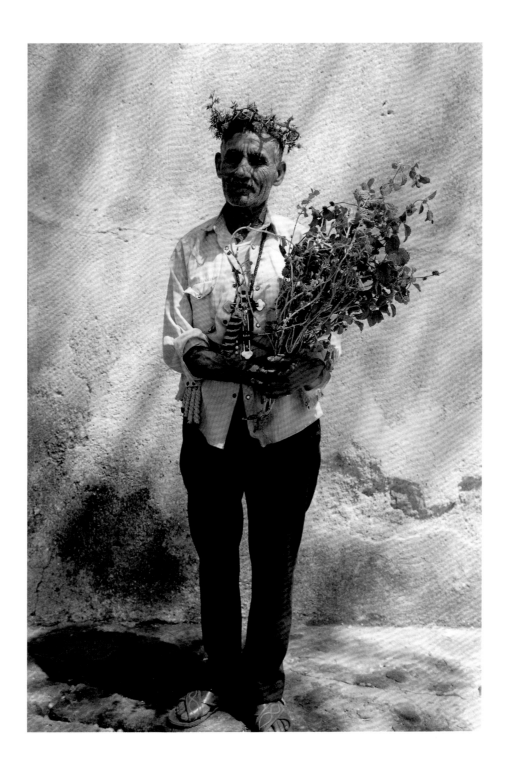

Flor y canto (flowers and song), recurrent themes of ancient Mexican festivals, remain key elements of Mexican fiestas today.

Opposite. A carved figure of Christ in a church (Atotonilco, Guanajuato).

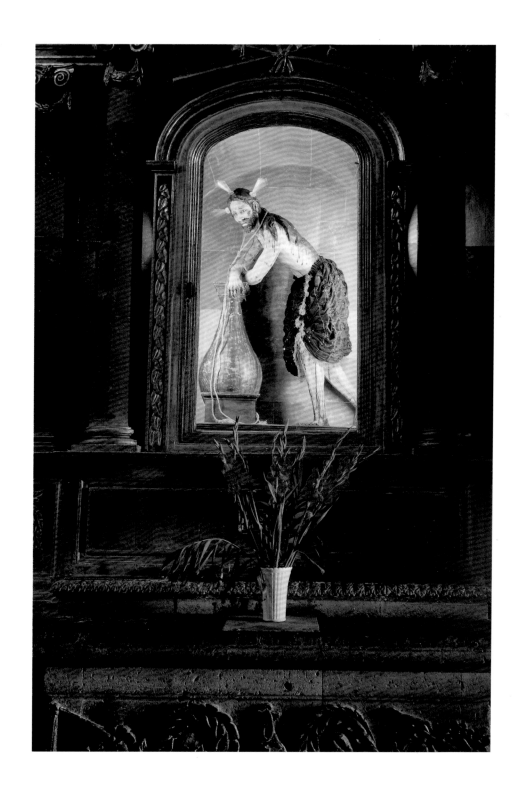

Los voladores (the flying pole dance), one of the most beautiful and dramatic of the Mexican dances, is many centuries old. A tall, straight tree, almost ten feet high, is set up in the middle of a plaza and topped with a rectangular revolving platform. Ropes for each of four *voladores* are wound around the top of the pole under the frame. With a rope tied around his waist, each flyer throws himself into space and spins in circles around the pole as the rope unwinds. One interpretation of the dance of the *voladores* has been as a representation of the Aztec calendar; thus, the thirteen revolutions around the pole that was the flyers' goal symbolized the Aztec cycle of fifty-two years, divided into four epochs of thirteen each. Another analysis saw the dance as an image of the coming to earth of the gods, to be among the people on festival days.

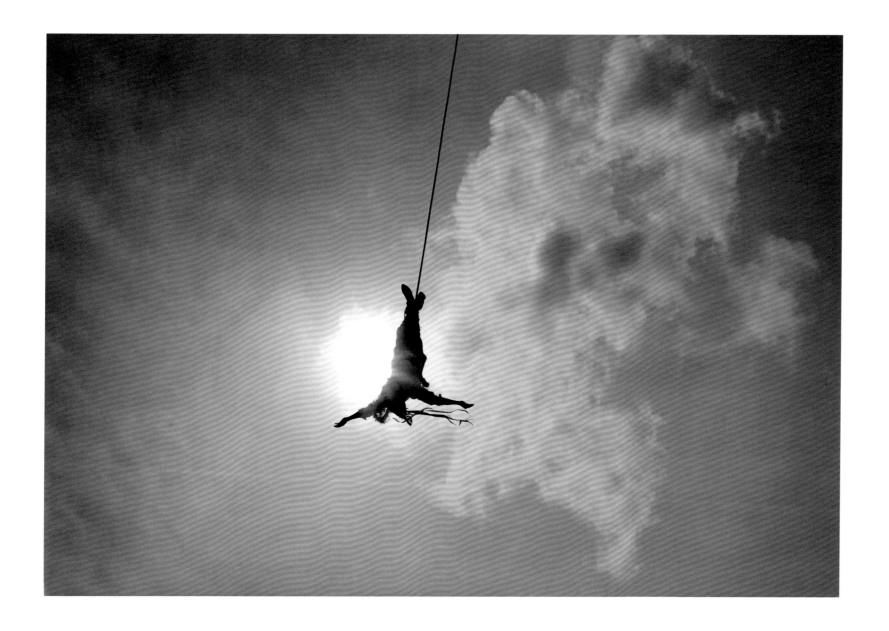

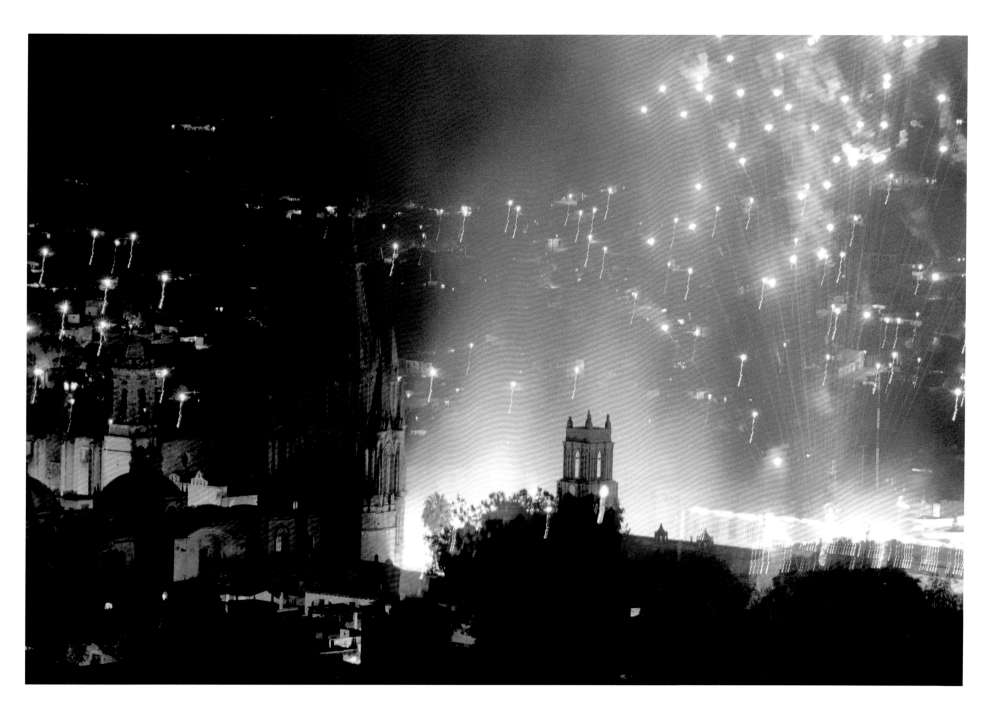

The fiesta of San Miguel begins each year at five o'clock in the morning with the *alborada*, an artificial dawn
created by the thousands of rockets and other fireworks exploded around the cathedral (San Miguel de Allende, Guanajuato).

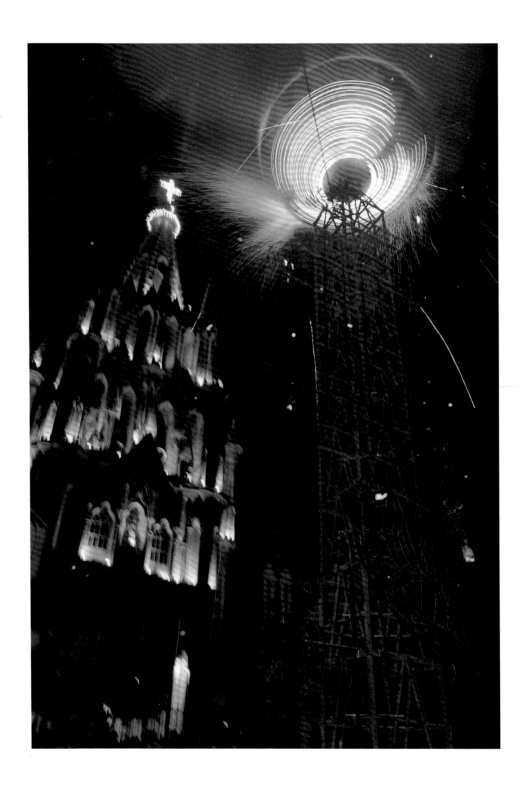

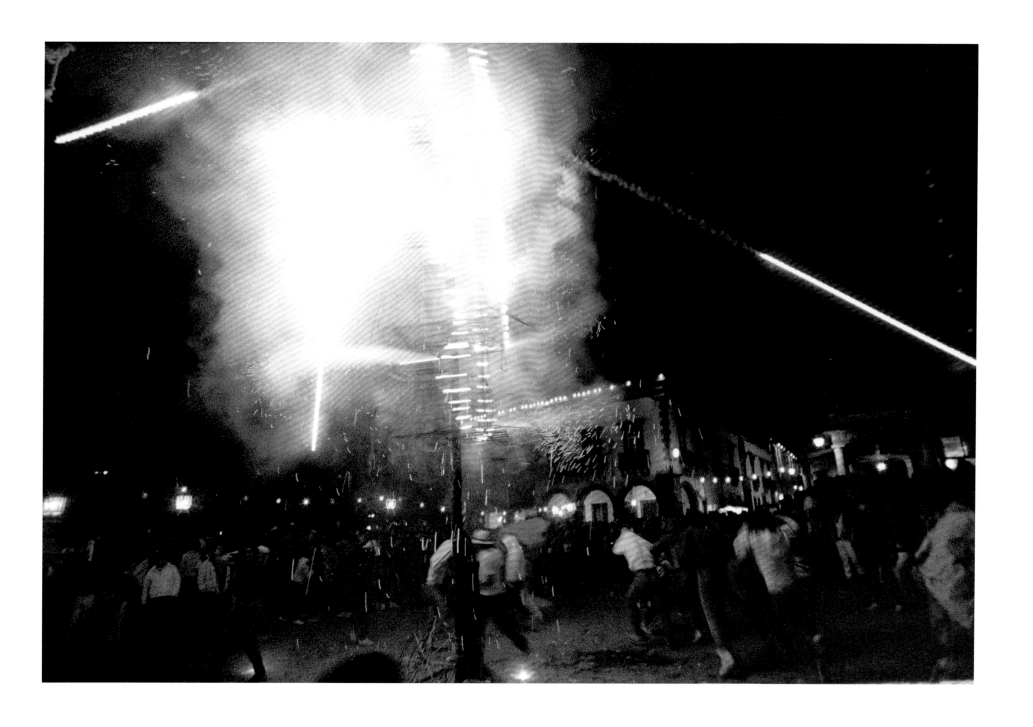

Pages 62–65. Fireworks and the celebration of mass in the local church mark the beginning of the fiesta of San Miguel. (Zinacapan, Puebla).

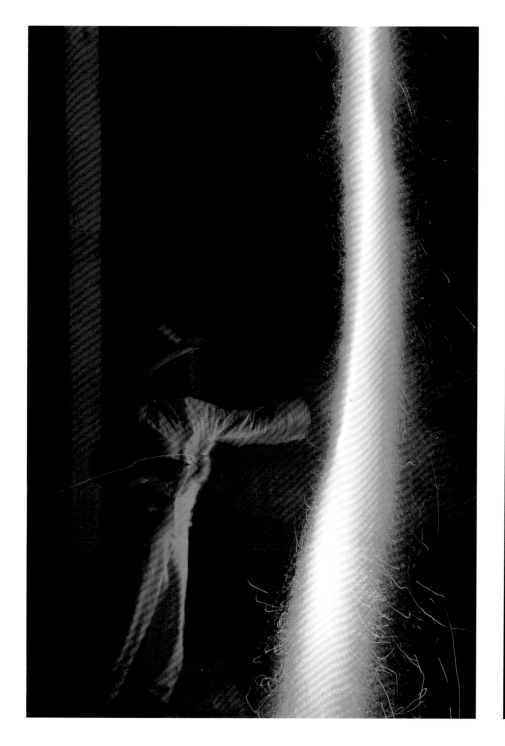
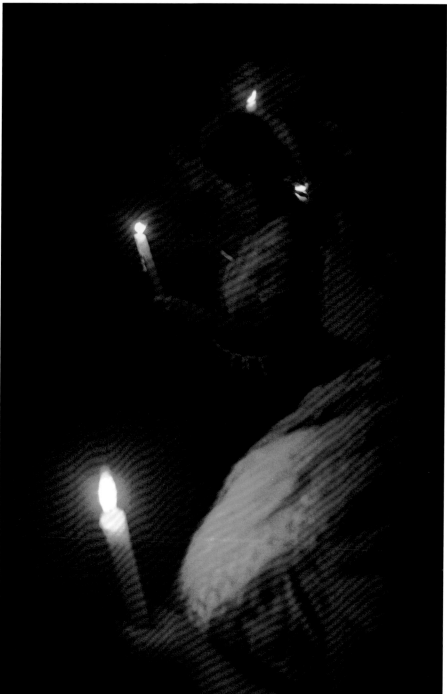

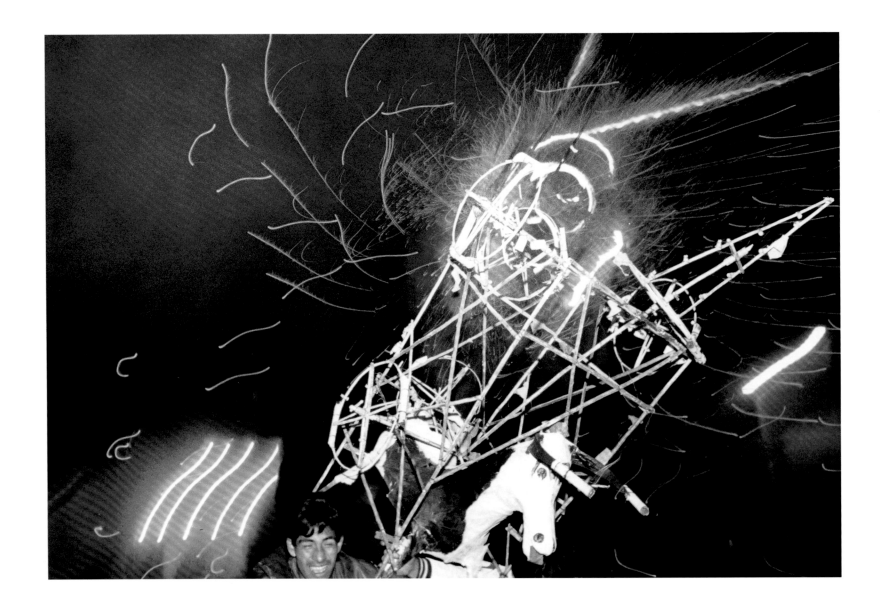

A young man runs with a *torito* (little bull), locally made construction of papier-mâché and cane in the shape of an animal onto which rockets are mounted. On fiesta nights, as the band plays, young men will grab a *torito*, light the rockets, and dance as the sparks fly in all directions (Tultepec).

Opposite. A man dances inside a *gigante*, a twelve-foot figure of a woman (Olinala, Guerrero).

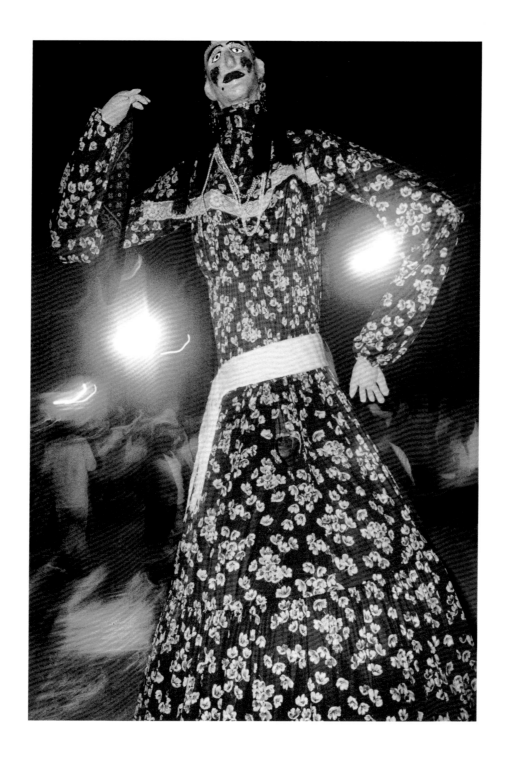

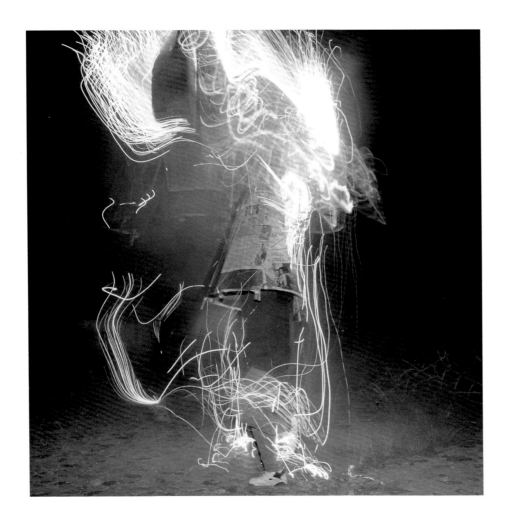
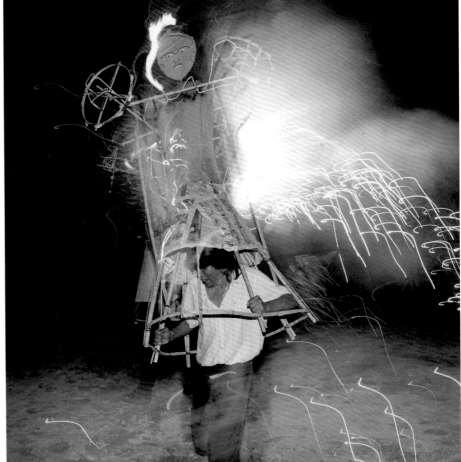

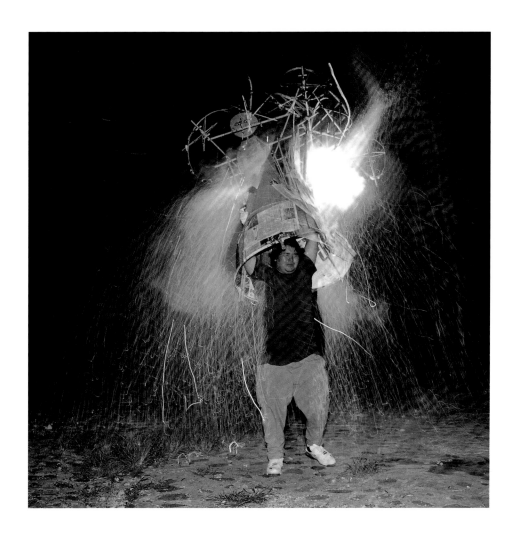
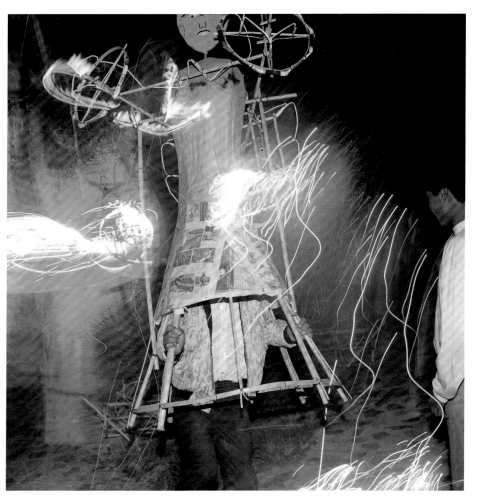

Men dance with *toritos* (Ocotlán, Oaxaca).

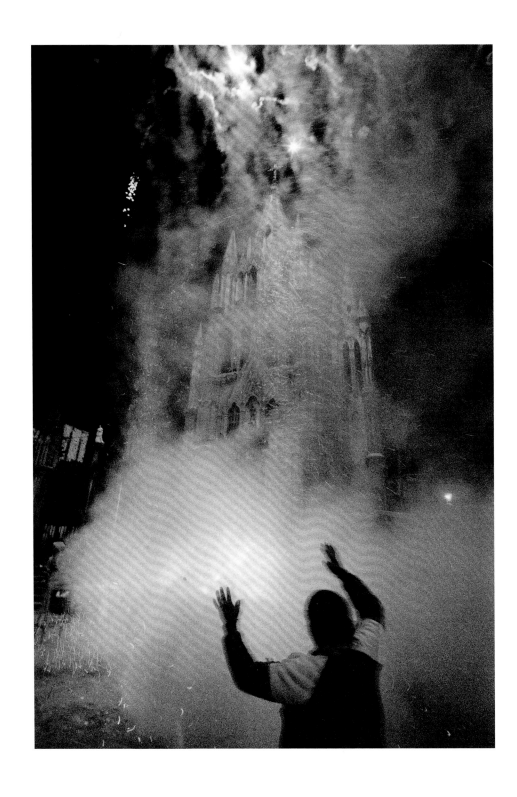

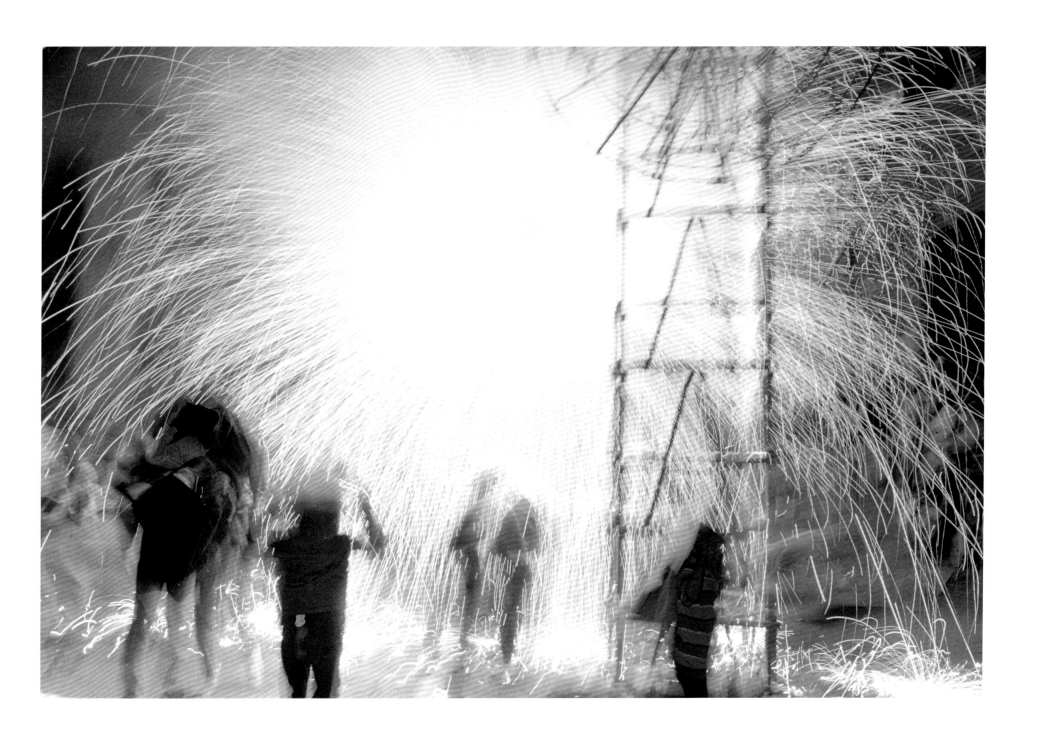

Fireworks light up the central cathedral and children run through a *castillo* (castle) of rockets during the *alborada* (San Miguel de Allende).

Todos Santos (All Saints) is a fiesta celebrated throughout Mexico on November 1
and 2. Commonly known as the Day of the Dead, it, like many Mexican fiestas,
can be traced back to pre-Hispanic times. The Aztecs celebrated two feasts of the dead
in the fall of each year: one, the Feast of the Little Ones, was in memory of children
who had died; the other, the Feast of the Big Ones, was for adults who had died.
Although the Spanish friars forbade the Indians to have feasts in the cemetery,
commemorations of the dead continued throughout Mexico, as the Indians changed
their dates to coincide with All Saints Day and All Souls Day on the Catholic calendar.
Today, the Day of the Dead is celebrated, with varying customs, everywhere in Mexico.
Rather than being macabre or frightening, it is a festive time of reunion.

Here, a trail of flower petals has been spread for the spirits of departed
souls to follow home from the cemetery. The brilliant gold petals of the *cempasúchil*
(the Náhualtl name for the Mexican marigold) are believed to draw and lead the spirits
both by their aromatic scent and by their luminous color (Zinacapan, Puebla).

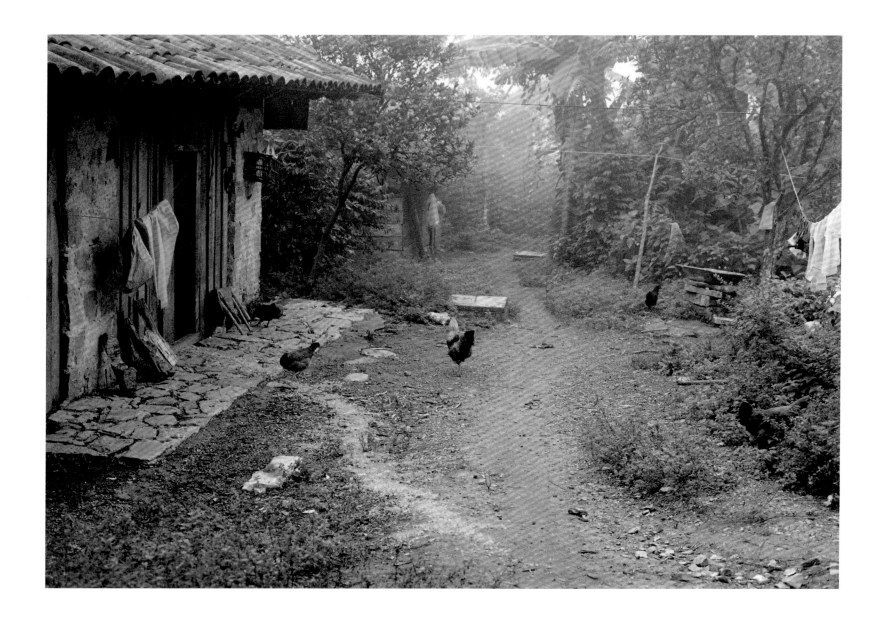

The trail of marigold petals crosses the threshold of the home and leads across the dirt floor toward the *ofrenda* (altar).

The *ofrenda*, made in honor of the dead members of the family, will be constructed on October 30 or 31. By November 1, when the spirits arrive, it will be covered with all the favorite things of the dead who are being honored: breads, fruits, tamales, brandy, mescal, fiesta costumes and masks, cigarettes, and flowers. Native people believe that the spirits of the dead will partake of the essence of the offering, which will then be consumed or used by the living. On these two sacred days, the family will be at home to greet the spirits and any other guests who might arrive. The traditional incense, copal, will be kept burning in the home. One common belief still found throughout Mexico is that returning spirits may arrive in the form of other living creatures. Perhaps for this reason, all guests, including animals, are treated with special hospitality and kindness.

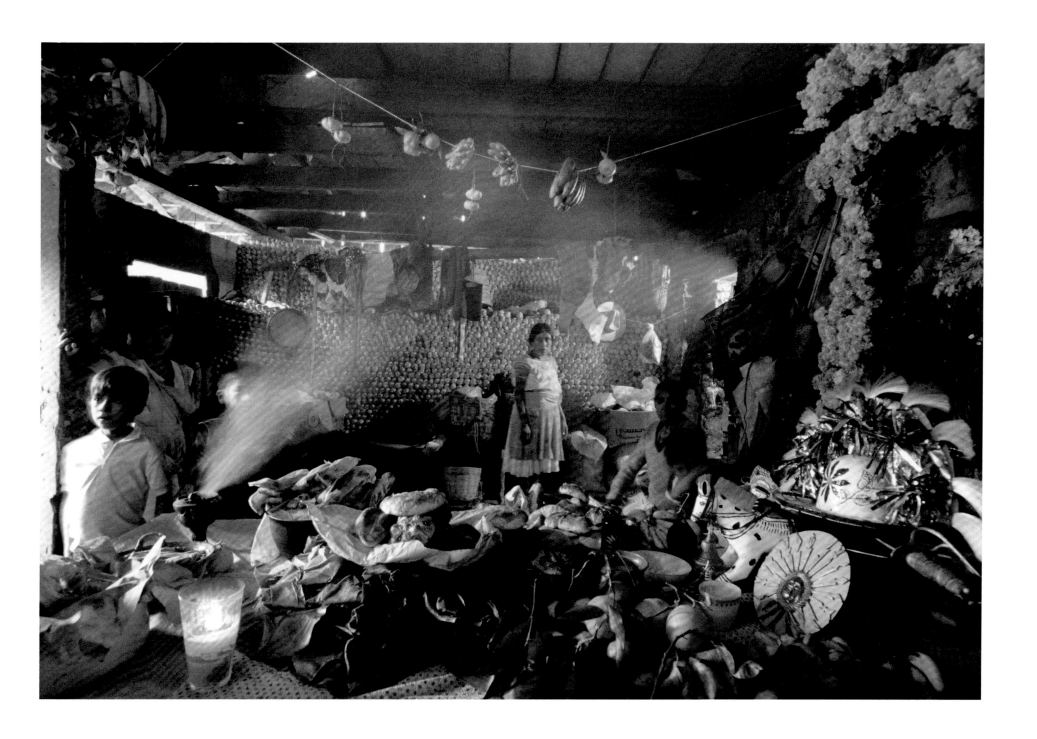

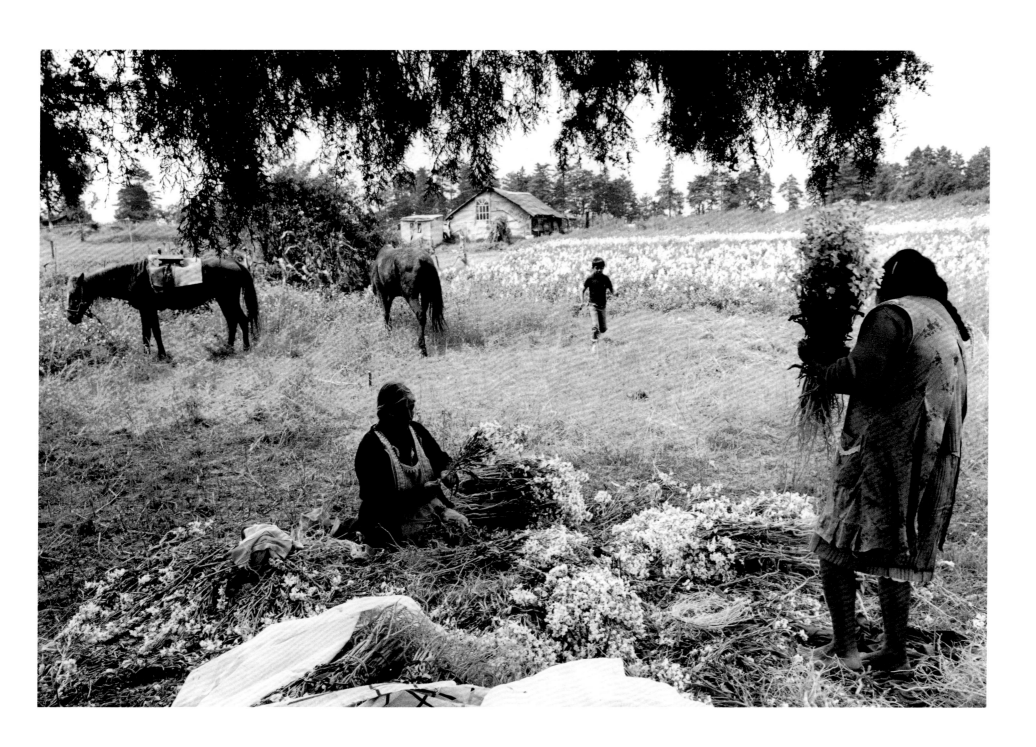

Women and children gather flowers in the countryside to decorate their homes for the Day of the Dead (Amecameca, Puebla).

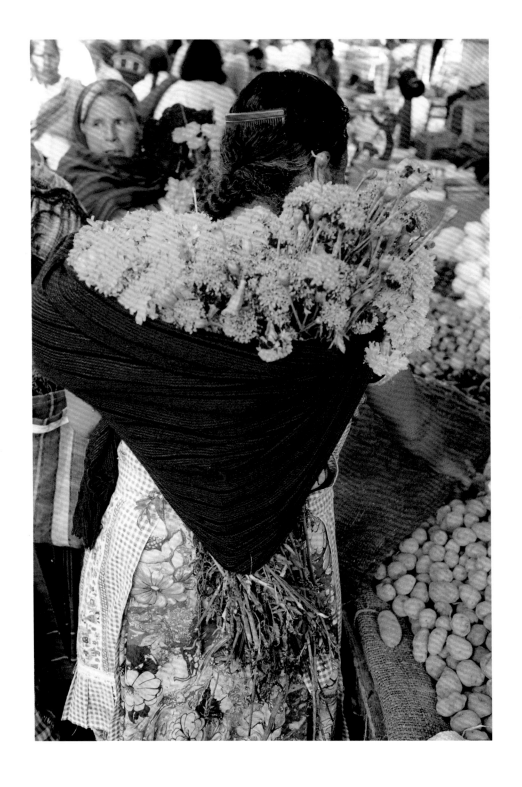

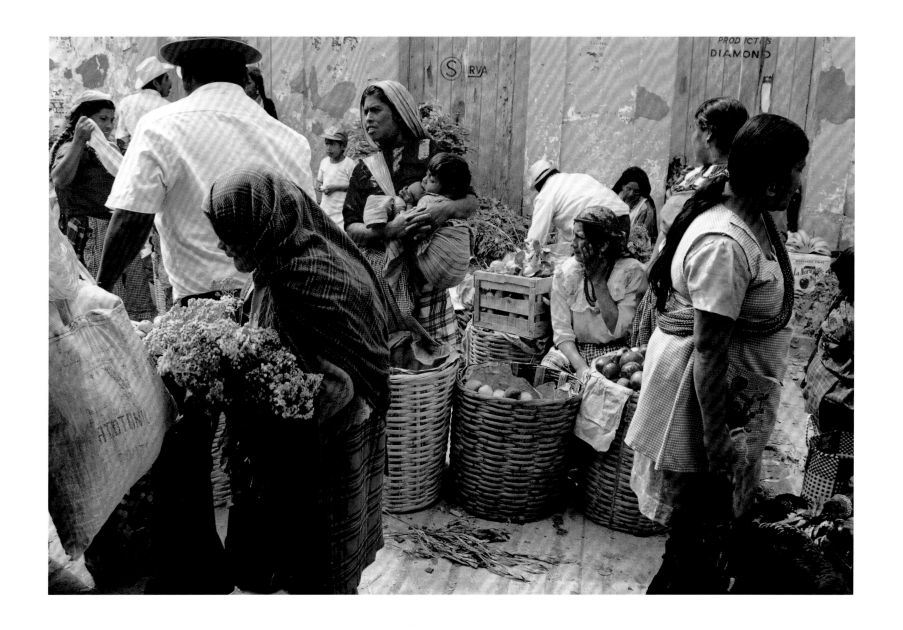

Pages 80–83. The village and rural markets in the week before the Day of the Dead offer the widest variety and the finest goods of the entire year. Flowers and decorative flora of every type abound. All the ingredients for mole, *atole*, tamales, and other traditional foods are available in abundance. The markets are jammed with people through the afternoon of October 31, when everyone heads home to greet the spirits.

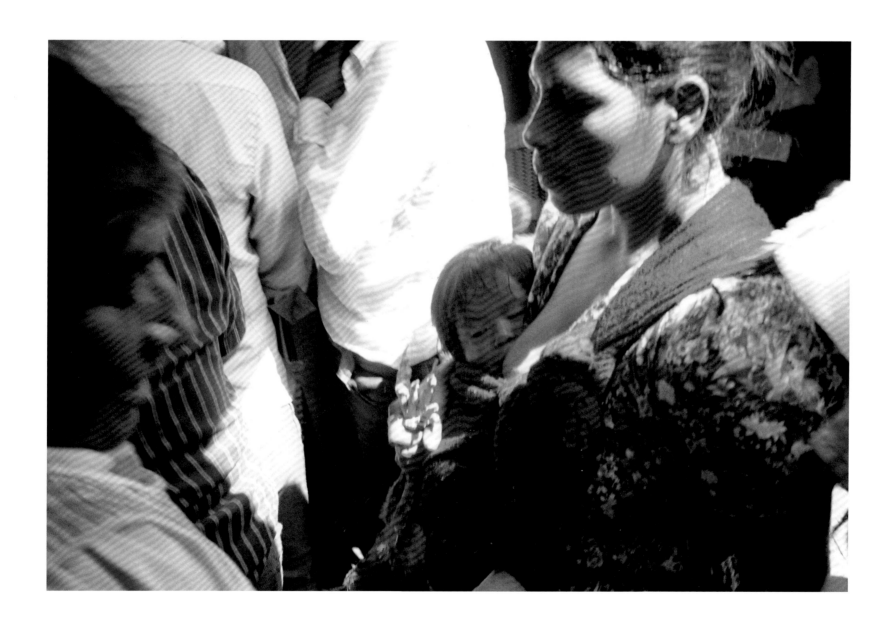

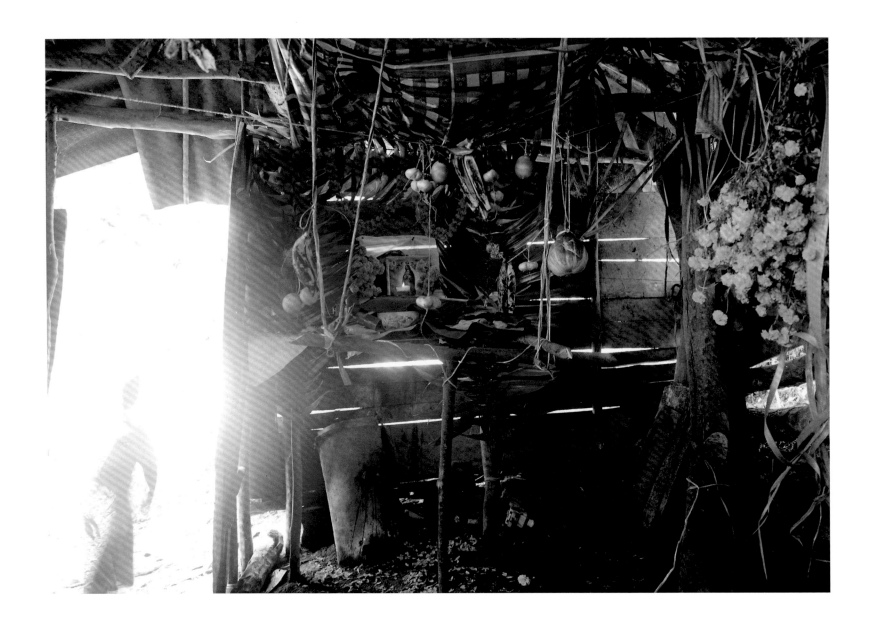

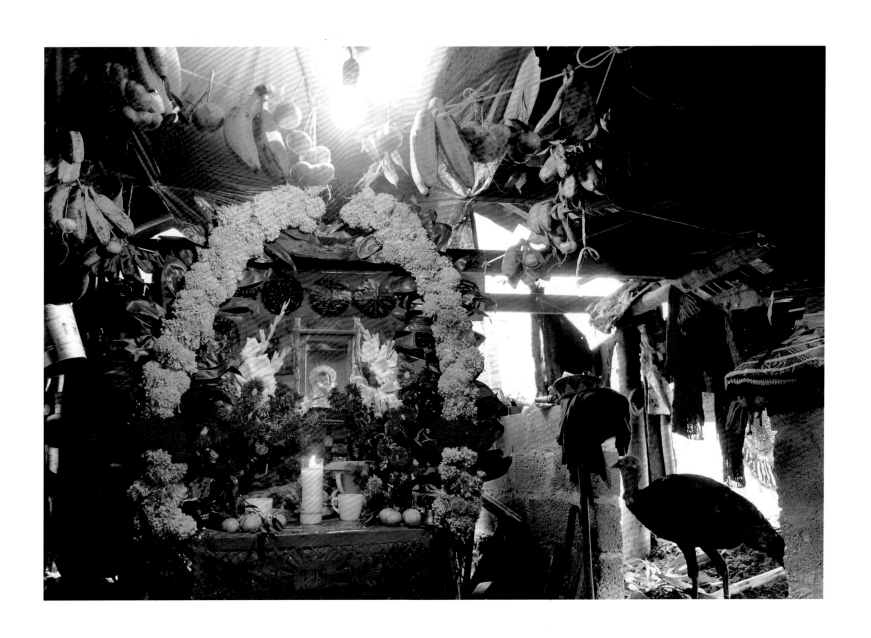

Two *ofrendas* are set up in homes for the Day of the Dead (Zinacapan, Puebla).

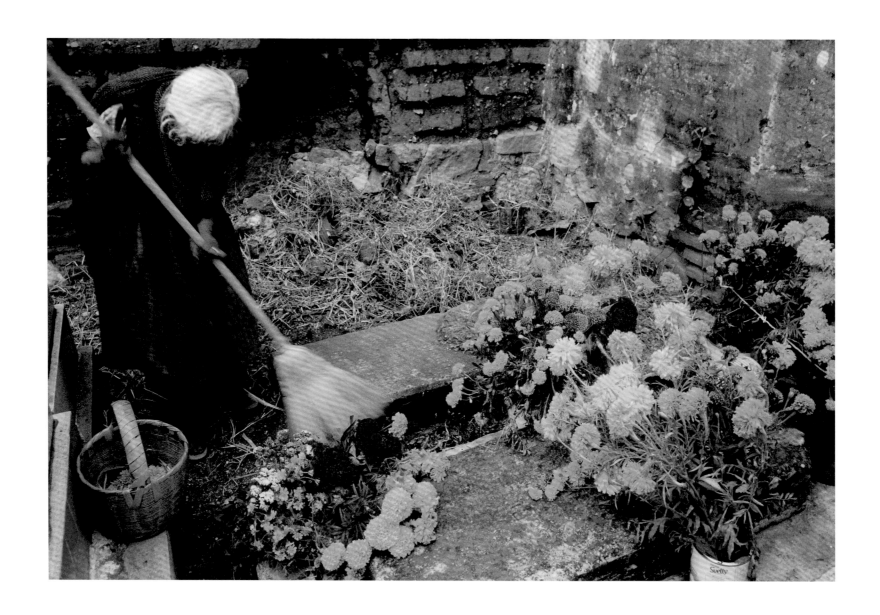

On October 31, the day before the arrival of the spirits of the dead, the living go to their local cemetery to clean the graves of their departed family members. The elderly woman here sweeps the grave of her departed sister (Xoxocotlán, Oaxaca).

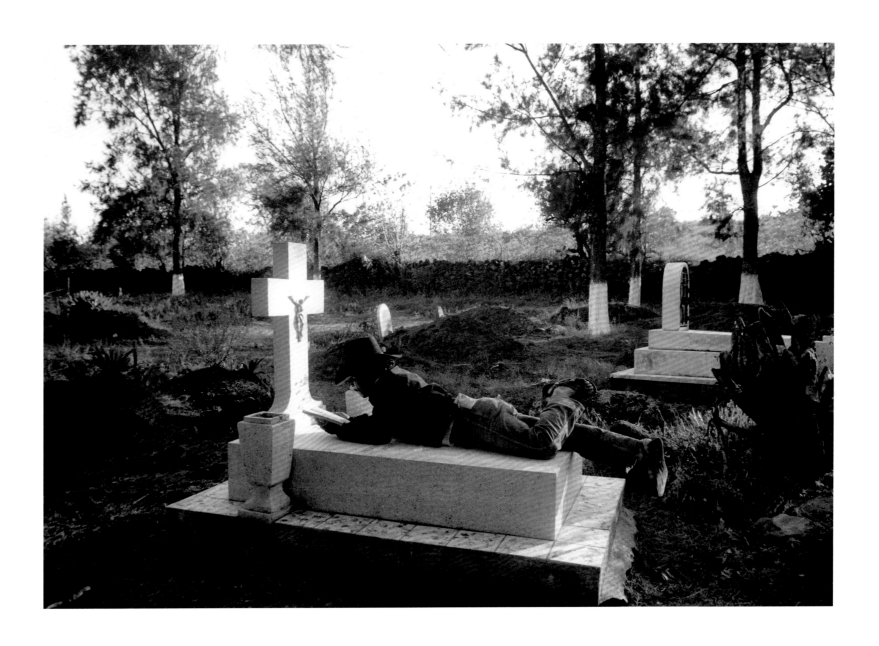

A man takes a break from his work in the cemetery in on the day before the Day of the Dead (Tzintzuntzan, Míchoacán).

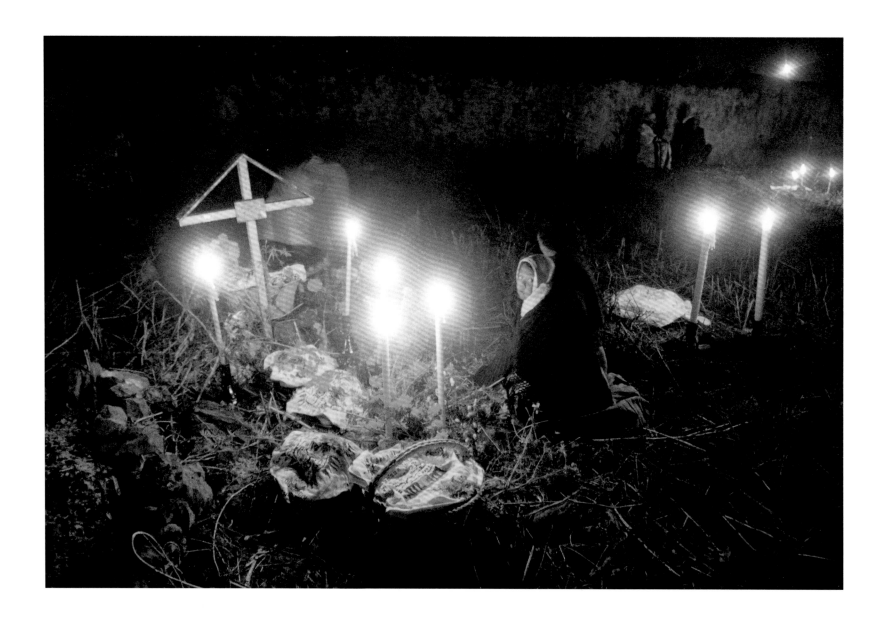

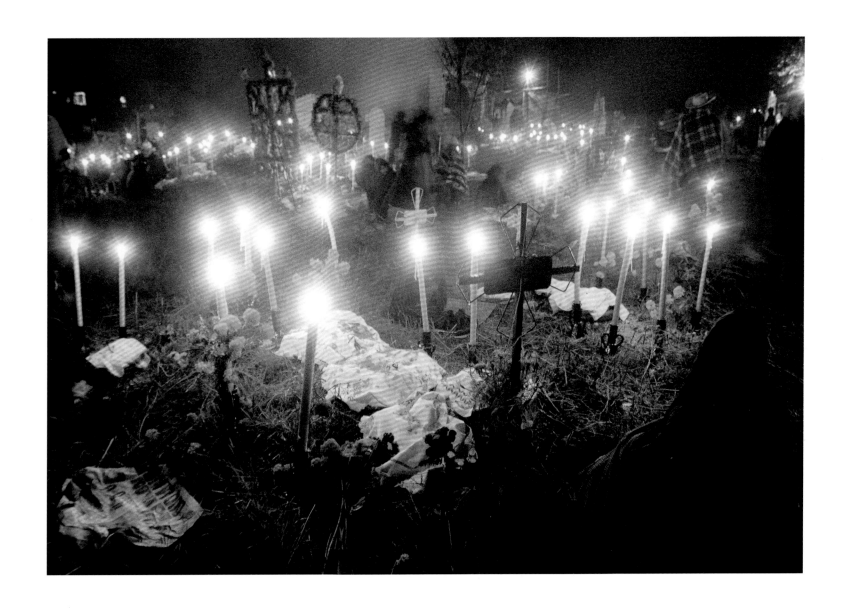

In parts of the state of Míchoacán, particularly in villages located around Lake Pátzcuaro, families keep an all-night, candlelight vigil in their cemeteries on the night of October 31. Each cemetery is lit by thousands of candles that burn until dawn, when the spirits arrive and are escorted home by their families.

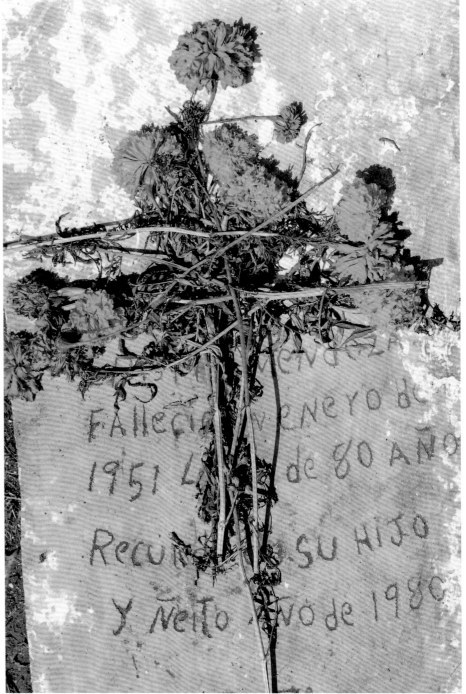

90

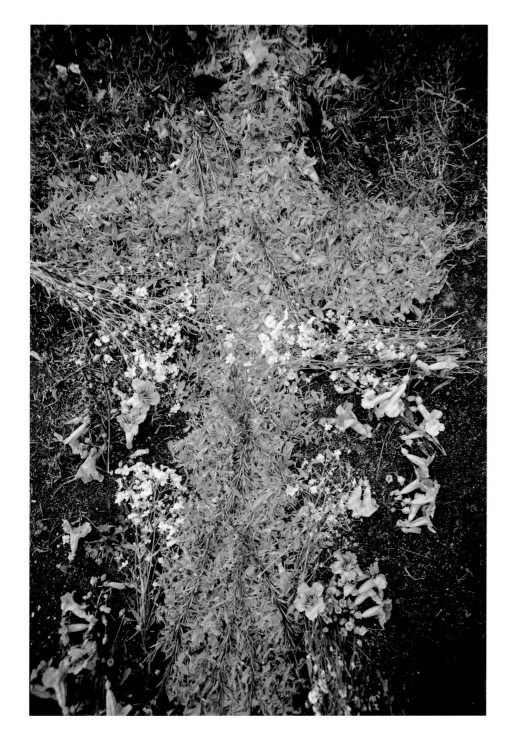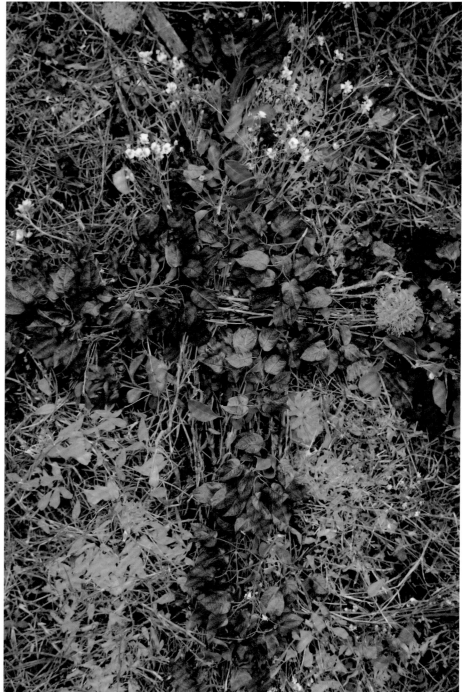

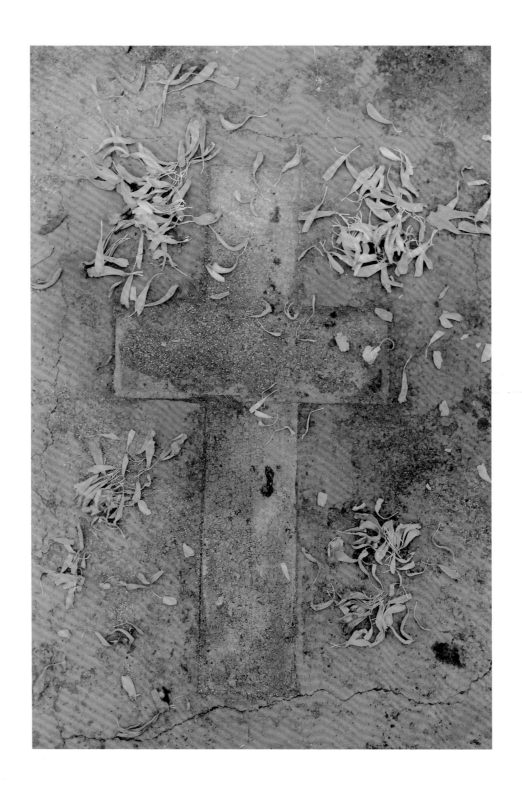

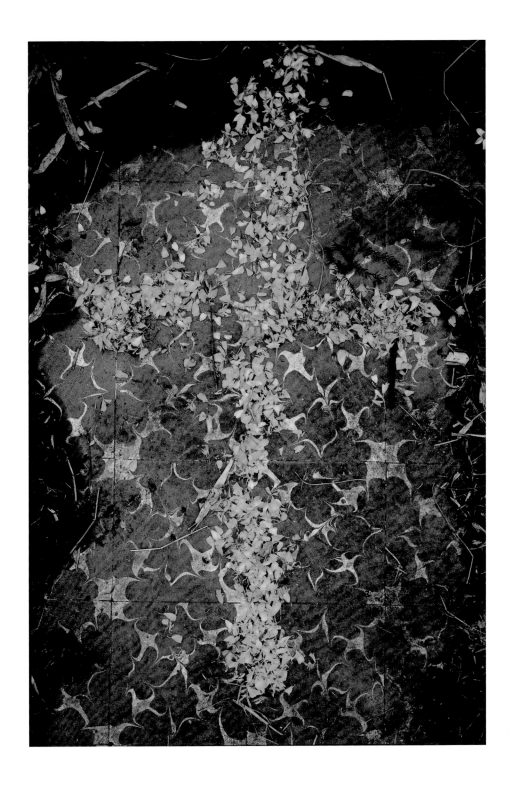

Pages 90–93. On November 1 and 2, graves all across Mexico are covered with flowers.

Acknowledgments

The photography for this book was done over an eleven-year period
from 1984 to 1995. I wish to express my gratitude to the institutions and
individuals who helped make possible the completion of the project,
this book, and the traveling exhibitions that accompany it.
My deepest appreciation to:

Vinson & Elkins, L.L.P.

Gay Block

Travis and Suzann Broesche

Mayor, Day, Caldwell & Keeton, L.L.P.

Ben and Sara Powell

Tesoros Trading Company

Bracewell & Patterson, L.L.P.

David Ruttenburg

W. Thomas Taylor

Marie Fay Evnochides

Stephen and Karen Susman

American Breco Corporation

Marvin and Norma Myers

Rice University, Division of Humanities,

Allen J. Matusow, Dean

I also want to express my appreciation to all the families and individuals
throughout Mexico who welcomed me into their homes, befriended me, and shared
their fiestas with me, especially to the family of Miguel de los Santos of Zinacapan,
Puebla, and the family of Felix Gonzales of Teotitlán del Valle, Oaxaca.

Finally, I want to thank my friend, the Mexican photographer Augustín Estrada,
who on innumerable occasions informed me, guided me, taught me,
and so generously shared his beautiful country and its people with me.

Geoff Winningham

Design and typography, Tina Davis, New York

Printed and bound by Arnoldo Mondadori, Editore, S.p.A., Verona, Italy